MARINE ARTISTS
OF BRISTOL

NICHOLAS POCOCK 1740-1821
JOSEPH WALTER 1783-1856

Francis Greenacre

City of Bristol Museum and Art Gallery

Acknowledgements We are very grateful to the owners who have permitted their pictures to be reproduced. Many people have assisted with the preparation of this small book but we are especially indebted to the staff of the National Maritime Museum, of the City of Bristol Record Office, and of Avon County Reference Library, and also to Paul Elkin, J. C. G. Hill, Mrs Deborah Olson, N. R. Omell, and to the Society of Merchant Venturers. A selected bibliography has been included but particular acknowledgement must be made to the publications of Commander J. W. Damer Powell, Grahame E. Farr and David Cordingly.

Published by the City of Bristol Museum and Art Gallery on the occasion of the exhibition: 'Bristol's Marine Artists' 17 November – 15 January 1982/3 as a contribution to Maritime England Year 1982.

ISBN 0 900199 19 9
Designed by Kathryn Gilmour of the City of Bristol Museum and Art Gallery.
Printed by the City of Bristol Printing and Stationery Department.

Cover: Detail of *The Mouth of the Avon* by Joseph Walter (pl. 50)

CONTENTS

Introduction

For several centuries Bristol was England's second port. From the mid-eighteenth century her importance began to decline only in relation to other faster-growing ports such as Liverpool. For nearly a hundred years or more, there was expansion of the docks within the city and it is this period of great change that the works of Pocock and Walter record.

Their drawings, paintings and engravings provide some of the most immediate and evocative evidence of the maritime history of Bristol. It is the intention of this small book to make these records better known. The pictures range from the amateur drawings of privateers, ships that are so suggestive of the enterprise and opportunism of Bristol's merchants, to the engravings of the S.S. *Great Western* and S.S. *Great Britain,* steamships launched in Bristol but too large to risk returning to the city. Pocock's drawings of slave ships and his paintings of views and sea-battles in the West Indies remind us of the source of much of Bristol's wealth at the beginning of this period. Walter's very much later views of Bristol's docks depict crowded quays but little activity, and hulks are much in evidence. The merchantmen and men-of-war being towed so laboriously up and down the Avon in Pocock's views are later superseded by sleek steam packets in some of Walter's paintings. But both artists took particular delight in the crowded drama in Kingroad at the mouth of the Avon when ships hastened to take advantage of a favourable wind or tide.

There have been other exhibitions and essays devoted to Nicholas Pocock. But this is the first time that it has been possible to follow the fascinating progress of his work from the naîve drawings of a young mariner to those of a ship's captain and thence beyond the early professional pictures, to the mature works of an independent and established artist. Many of the earliest works are here attributed to Pocock for the first time and the attribution makes possible the dating of some drawings of historical importance. No attempt is made to follow Pocock to London in 1789 in his fiftieth year, except for the inclusion of his largest work, a painting of 1790, which has strong Bristol connections.

Joseph Walter has suffered the indignity of being confused with members of the Walters family, lesser artists from Liverpool. But more recently E. H. H. Archibald has called him the best marine artist that never moved to London. He came from a humbler background than Pocock and his ambitions were more modest although his talents, if not his achievement, were just as considerable. This is the first occasion on which his work has been examined in any detail.

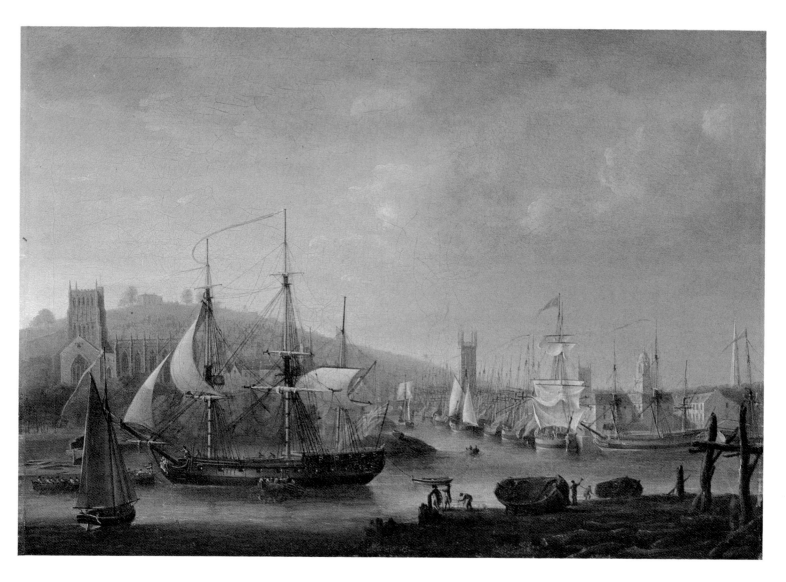

Nicholas Pocock: Bristol harbour with the Cathedral and the Quay, 1785 *see page 64*

NICHOLAS POCOCK

The tablet on Nicholas Pocock's tomb in the parish church at Cookham, near Maidenhead, bears the dates '1741 – 1821', and the briefest of obituary notices in the *Gentleman's Magazine* notes that he died in his eighty-first year on 9 March. Recent research has, however, established that Pocock himself believed that he was born in 1740 and it is this date that should now be preferred.

Apprentice mariner, 1757 – 64

There is no doubt that on 28 May 1742 Pocock was baptised almost within sight of the quayside in St. Stephen's Church, Bristol. In the same year his father was admitted to the freedom of the city by virtue of his marriage to Mary Innes, the daughter of a freeman. When, in 1757, Nicholas was apprenticed for seven years to both his parents, Nicholas and Mary, his father was described as a 'mariner'.

Pocock's father died in 1759, leaving a widow and four sons of whom Nicholas was the eldest. One brother died aged sixteen, a prisoner of war in Spain. The other two, William Innes and Isaac, were both described as mariners when they were admitted as freemen and each of the three surviving sons was to take command of one of Richard Champion's ships. The Pococks owed much to this remarkable man.

Richard Champion, protector

Richard Champion, 1743 – 91, a Quaker, was a Bristol merchant trading with America and the West Indies. He was to be the leading Whig in the city, a close friend of Edmund Burke and one of America's staunchest allies. He was the manufacturer of Bristol Porcelain and it was to be the costs of this factory and of the defence of the patent for true porcelain, as well as the disastrous effects upon trade of the American War of Independence that led, in 1778, to his temporary insolvency. He later emigrated to America, where he died.

On 1 August 1775 Nicholas wrote gratefully to his employer from Dominica whence he had captained Champion's ship, the *Lloyd*:

> 'I must say how happy I am to see my good mother easy and healthy owing to her being free from care and the pleasure of seeing those boys, by your friendship and their endeavour in good situation, for they were, when I first knew you, young and friendless and my mother left in some difficulties which you have enabled me to get her out of.'

Champion's sister confirms the importance of this friendship recalling in her journal that Nicholas:

> 'was a young man who had been some time in my brother's employ; one of three brothers whose mother was a widow supported by this son. He was much caressed by us all. In the intervals when he was not at sea, he spent much time at my brother's and never seemed happy but when there. Having a fine taste for drawing, he sometimes talked of giving up the sea'.

When exactly Pocock entered Champion's employment is uncertain, but there is no evidence that it was before 1766. For the ten years from 1757 when he was apprenticed to his parents, only his earliest drawings give hints of his activities during his first years as a mariner.

Early drawings, 1758 – 62

Nicholas Pocock's first signed and dated drawing bears the date 1759 (pl. 2). A similar view of another Bristol privateer probably dates from 1758 (pl. 1). Two drawings dated 1762, of which one is illustrated here (pl. 8), are still rather stiff but they have an assurance that allows another six less confident and undated pen and ink and wash drawings to be dated to between 1758 and 1762 (pl. 3 – 6). Excepting the fascinating drawing of docks at Wapping in Bristol (pl. 6) all these early works depict Bristol privateers, or former privateers. Three of them include vignettes depicting the slave trade on the African coast. It is tempting to believe that some of the detail results from first-hand experience and it is entirely likely that a future ship's captain in the West India trade would have been involved at some time in the traffic of slaves. It was a trade, however, with which Richard Champion himself was not connected.

There are as yet no known drawings datable to the period between the years 1762 and 1778 excepting those contained in the remarkable series of logbooks. One of the very best of these volumes has returned to the City of Bristol after its recent acquisition by the Bristol Record Office (pl. 9 – 12).

Ship's captain, 1766, the logbooks

In October 1766 Pocock first captained the *Lloyd* and sailed to Charleston, South Carolina, for Richard Champion. On his return in February 1767 he arrived off Plymouth, where his anchors dragged and he ran aground. Much of his cargo was saved. No logbook survives for this first voyage but for the next ten years from 1767 to 1776, Pocock captained Champion's ships on twelve voyages which he recorded in seven illustrated logbooks. Out of gratitude and friendship for his employer, he lavished great care on these volumes. For almost every day of each voyage, he not only recorded his progress and the directions of the winds and changes of weather but drew a portrait of his ship from one of hundreds of varying angles, in whatever conditions prevailed during the day. A few days are missed and on others the small but carefully finished pen and ink drawings are replaced by watercolours of a dolphin, cuttlefish or some strange bird that landed on the deck.

Nicholas Pocock's first six voyages for Champion, between 1766 and 1769, were in the *Lloyd* to Charleston. In 1770 he sailed in the *Betsey* to Cork, Cadiz, Leghorn and London. In 1771 – 2 he sailed twice to Dominica in the West Indies in the *Lloyd,* and between 1772 and 1776 made four further voyages to the West Indies in the *Minerva*. The last voyage was to Nevis and there is no doubt that Pocock was entirely familiar with the lands and waters he was later to paint so often.

His character

The logbooks tell us little of Pocock himself. But on his arrival at his destination he would send a letter to his employer on the first boat leaving port. Copies of some of these letters survive in Champion's letter books. They go beyond mere confirmation of the implications of Sarah Champion's remarks in her journal. She had written that Pocock seemed only happy when staying with her brother and had added:

> 'Although not highly educated he was a stranger to that failing too often attendant on want of mental culture; for I have generally remarked that ignorance and conceit usually accompany each other, but this, Captain Pocock's good sense and diffidence preserved him from'.

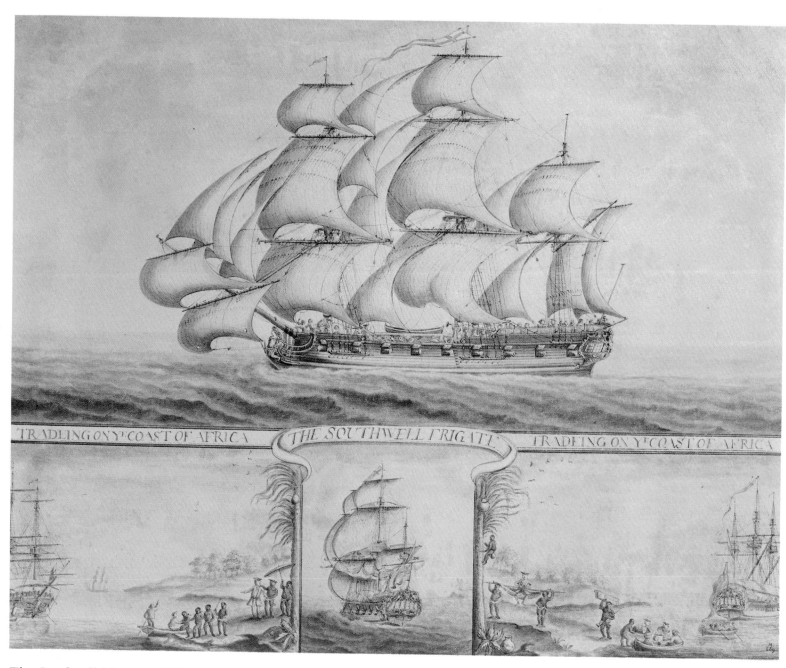

TRADEING ON Yᵉ COAST OF AFRICA THE SOUTHWELL FRIGATE TRADEING ON Yᵉ COAST OF AFRICA

8 The *Southwell* frigate, *c.*1760 *see page 19*

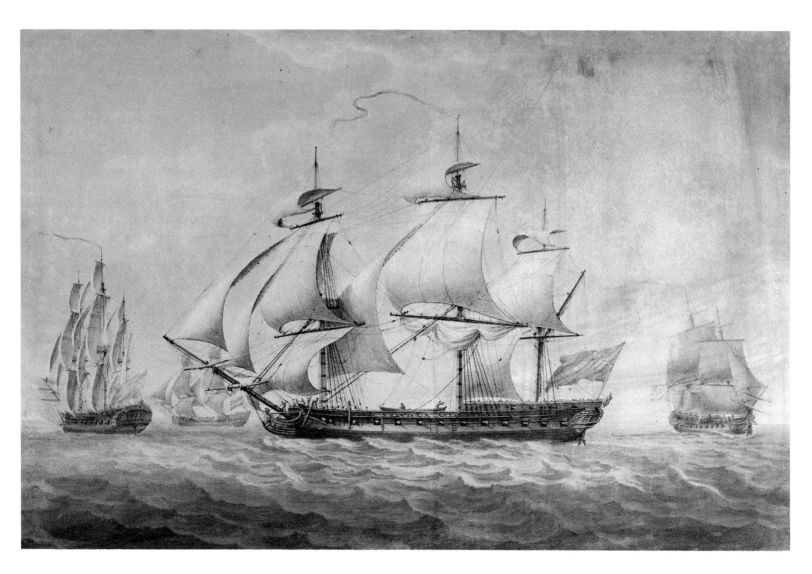

The *Lord North* with her prize, 1782 *see page 35*

The letters suggest more than diffidence. They are extraordinarily introspective epistles, sometimes making no reference to the voyage or to trade and perhaps making only very brief mention of a hurricane or an earthquake. Repeatedly they return to the theme of friendship:

> 'I consider that I do not write a letter to you, but a copy of my thoughts and feelings just as they occur, and which I think if I were to disguise I should be unworthy of that friendship I glory in and in which I am so happy'.

On this occasion, 6 January 1773, Pocock ends by saying that 'I am in a better temper with this world than I used to be' but then states that he has drunk too much wine. On an earlier occasion he admits to 'a depression of spirits custom has never been able to assist in curing' (9 March 1772). Another time he ends a particularly rambling letter: 'I conclude for I know you wish me too well to like me in this humour. . . .' (probably March 1771). Most expressive of all is a letter from Dominica on 25 February 1771. Pocock begins by repeating profound gratitude for Champion's friendship, despite 'a difference of situation in life'. He concludes:

> '. . . I am not in great spirits at present, is it constitution or must I think less? Though I have too much softness in my nature, I dare do all becomes a man; nor is it a boast for if I did not I should not think myself worthy to subscribe myself, Dear Sir, Yours etc. . . .'.

Ends life at sea

In due course a check of the Muster Rolls at the Society of Merchant Venturers will tell us whether or not Pocock was to continue as a master mariner after the close of his voyage to Nevis in June 1776. His first voyage in the *Lloyd* ten years earlier had followed the repeal of the Stamp Act and a great upsurge of trading. Now the Declaration of Independence was just about to be signed, and in a few months Pocock's brother Isaac, captaining the *Marquis of Rockingham* was to be captured by the Americans. Champion had defied his Quaker principles and put a few guns aboard his vessel for its defence, but to no avail. It is very possible that Nicholas Pocock chose this moment to change his profession. Alternatively he may have continued until the declaration of his protector's insolvency in 1778. It is most unlikely that he continued as a mariner beyond that year.

In 1778 Pocock drew a portrait of the *Cumberland*. Its quality shows no advance nor its technique any development since the last dated ship portraits of 1762. But the drawings of the *Arethusa* of 1781 and the *Lord North* of 1782 are very much more lively, delicate and sophisticated drawings. They are also watercolours, albeit very faded, rather than monochrome drawings. Pocock's art, now that he was devoting all his time to it, developed fast.

On 3 February 1780 Pocock married Ann Evans. The licence describes Nicholas as 'Gentleman'. His bondsman was Christopher Deake, a ship's captain, who was to marry Pocock's sister. Since before 1775 Pocock and his mother and her family had lived at 41 Prince Street and here the Pococks almost certainly remained until 1789.

First oil painting

It may have been his marriage that delayed the sending of his first oil painting to the Royal Academy. On 4 May 1780 the President, Sir Joshua Reynolds, wrote to Pocock announcing that the painting had arrived too late for inclusion. Reynolds continued:

> 'It is much beyond what I expected from a first essay in oil colours: all the parts separately are

extremely well painted; but there wants a harmony in the whole together; there is no union between the clouds, the sea, and the sails'. Reynolds concluded by recommending that Pocock should follow Claude Joseph Vernet in his ability to unite landscape with ship painting. Several years later Pocock was certainly to borrow a Vernet composition (pl. 37, 45) and he probably now immediately heeded Sir Joshua Reynolds' advice. In 1782 the Royal Academy accepted four of his works of which the first was an oil painting of a costal scene off Martinique.

Watercolours and engravings of Bristol and the Avon

Two of the other three exhibits at the Royal Academy of 1782 were Bristol harbour scenes in watercolour, drawn in 1781 (pl. 16, 17). They are tinted pen and ink drawings. In one some of the figures and a leaping dog might well have been copied from a seventeenth-century Dutch drawing or engraving.

These Bristol views were evidently successful, for Pocock was soon beginning a series of large watercolours of views of the Avon (pl. 16 – 21) and watercolour versions over slight etched outlines began to appear in some numbers in 1782 (pl. 22 – 29). For these engravings Pocock quickly and subtly improved his first compositions. His watercolour technique also improved and the tinted drawings, in which the colour is washed into monochrome outlines, give way to watercolours drawn directly in colour.

Some of Pocock's watercolour sketches (pl. 30, 31) have a breadth and confidence and a feeling for the transient effects of light that suggest he also followed still more of Reynolds' advice, given in that early letter:
'I would recommend you, above all things to paint from nature instead of drawing; to carry your palette and pencils to the waterside. This was the practice of Vernet whom I knew at Rome; he then showed me his studies in colours, which struck me very much, for that truth which those works only have which are produced while the impression is warm, from nature . . .'.

There are earlier views than Pocock's of Bristol's shipping and of the Avon Gorge. The presence of the spa at Hotwells inevitably created a demand for records of the surrounding scenery. But no artist had before so diligently and sympathetically drawn the beautiful approaches to Bristol's harbour. Many of the viewpoints which he carefully selected were to be endlessly used by other artists for another hundred years. It was perhaps partly due to the success of Pocock's watercolours and engravings that between 1789 and the end of the century Samuel Hieronymus Grimm, Francis Wheatley, J. M. W. Turner, John White Abbot and Thomas Girtin were all to visit Bristol. It was Pocock, above all, who established the exceptional pictorial possibilities of the Avon from Bristol to the channel.

During the later 1780s and the early 1790s Pocock produced and exhibited many large landscape watercolours, often rustic scenes with no maritime content. He looked closely at the work of Thomas Morland. As late as 1803 he exhibited *A landscape with a gang of gypsies, from nature* at the Royal Academy and he continued for many years to make sketching expeditions to Wales.

Sea battles and the West Indies

The fourth picture in Pocock's first group of exhibits at the Royal Academy in 1782 was a portait of the *Arethusa,*

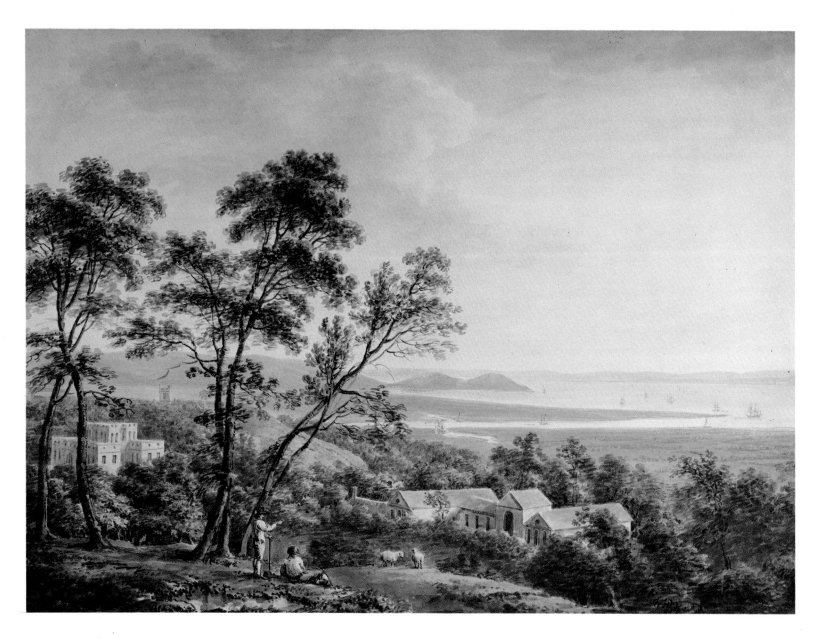

View over Kingsweston towards the Bristol Channel, *c.*1785 *see page 42*

a king's ship built in Bristol by James Martin Hilhouse. The drawing was commissioned by Hilhouse in 1781, and during the following year Pocock was to paint, probably under Hilhouse's direction, the two large views of the Battle of the Saints of 12 April 1782 (pl. 38, 39). He was to paint a further view of the battle (pl. 40) and to have it engraved. In the following year Pocock was also to produce a series of watercolours of the Battle of the Saints (National Maritime Museum) and of other engagements in the West Indies that preceded it (British Museum). Of the several oil paintings of these scenes, the finest was certainly the *Battle of Frigate Bay, 26 January 1782* (pl. 42). It was exhibited at the Royal Academy in 1788 and has a rare combination of drama, clarity and accuracy.

In the background of that painting is a view of Nevis, an island that Pocock knew well and which he painted on several occasions (pl. 45, 46). The preponderance of West Indian views, whether battle or coastal scenes, reflects not only the interest of Pocock's customers, many of whom were Bristol merchants in the West Indies trade, but also his determination to paint what he knew best. Such specialisation would have enhanced his reputation and when he moved to London he had doubtless already acquired an extensive clientele of retired admirals and naval officers.

Moves to London, 1789

In 1789 Pocock and his family moved to 12 Great George Street in Westminster. He moved briefly to Bath in 1817, probably for medical reasons. Thereafter he lived until his death in 1821 near Maidenhead at the home of his late brother, Sir Isaac Pocock. Isaac, who had been captured by the *Sturdy Beggar* of Maryland, had subsequently made an extremely advantageous marriage. His house and his fortune passed to Pocock's eldest son, who had begun

his career as an artist before his inheritance had allowed him to be a dramatist.

During the 1780s Pocock's art had developed with great speed and variety. One might have expected the artistic milieu of London to provide much new inspiration. But Pocock was now nearly fifty years old and although he had much yet to achieve his art was not to develop significantly. His reputation did increase and amongst his fellow artists it was considerable. In 1804 he was one of the founder members of the Society of Painters in Water-Colour and two years later he turned down the presidency of that society.

Pocock was to be present at the Battle of the Glorious First of June in 1794 and the extent and accuracy of his records of Nelson's battles are unrivalled. Too often, however, he was unable to combine atmosphere and pictorial effect with historical truth, to which he was always to give first consideration. There were to be some outstanding marine watercolours and some fine smaller oil paintings. One, at least, is a masterpiece of English marine painting. Exhibited at the Royal Academy in 1803 and now in the National Maritime Musuem, the painting depicts a fleet of eighteen East Indiamen in the course of tacking in a strong wind while *en route* for China. It reflects a sound appreciation of the work of the Van de Veldes and a profound knowledge and feeling for the subject matter. It is the work of an experienced mariner and it is, as a result, one of the most exciting evocations of one particular aspect of Britain's maritime history.

Pocock's pictures of Bristol shipping over thirty years, of the city's trade and the events that affected it, and of the long and beautiful approaches to the harbour, combine to form a unique record that is equally moving.

1 "A VIEW OF YE DUKE OF BEDFORD PRIVATEER"

c. 1758

Pen and ink and wash, 16 x 21⅝ in.
Inscribed as the title
Collection of the Society of Merchant Venturers

The *Duke of Bedford,* of three hundred tons, twenty-eight guns and two hundred men, was built as a privateer in Bristol and launched in 1745. Her construction, several years after the outbreak of the War of the Austrian Succession (1739 – 48), was doubtless prompted by the declaration of the previous year, that vested sole interest in any prize with the captors. She was gratefully named after the First Lord of the Admiralty of the day.

In 1745 in company with three other privateers, the *Duke of Bedford* dogged a French convoy of one hundred and twenty merchant ships with eight men-of-war sailing westward. But after two days they were spotted and chased off without having cut out any prizes. It is recorded that she took a prize in 1748 *en route* for Jamaica.

In 1758 her name was changed to *Patriot* and it is therefore likely that this is Pocock's earliest surviving drawing. The charming but very naîve view of the ships being towed down the Avon Gorge shows the steep cliffs being worked by quarrymen.

2 "A VIEW OF THE RUBY: 1759"

Pen and ink and wash, 16⅜ x 21½ in.
Signed: *N. Pocock fecit*
Collection of W. A. C. Theed Esq., Combe Sydenham Hall

This drawing, Pocock's earliest dated work, was made when he was eighteen or nineteen years old. He was then an apprentice mariner and was clearly interested in both recording the vessel accurately and depicting the life of the ship. The pilot is just leaving and it is presumably Flatholm lighthouse in the distance. The captain waves goodbye, and a sailor in the *Ruby*'s boat doffs his hat. Behind the captain a seaman is perhaps being sworn in or may even be being whipped. Beyond him, commands are issued through a loud-hailer, and a sailor pipes.

Fleurs-de-lis are clearly visible on the sides of the quarterdeck. They suggest that this ship was a French vessel, the *Ruby,* that fought a fierce but indecisive five-hour battle with the much smaller Bristol privateer, the *Scorpion,* on 22 April 1757. Immediately following this engagement, the *Ruby* was taken by the man-of-war, *Lowestoft,* and we presumably see her now refitted for action against her former countrymen. In the 1760s the *Ruby,* perhaps this vessel, was trading to Jamaica for Henry Bright of Bristol, and it has been stated that Pocock was at one time a captain in the employment of Lowbridge Bright, Henry Bright's nephew.

In the eighteenth century a privateer or private ship-of-war was a vessel expressly built or converted by its owner to take and to plunder enemy ships in times of war. A Letter of Marque, the necessary permission from the Admiralty which provided the commander with the right of attack, was granted to the *Ruby* in August 1758.

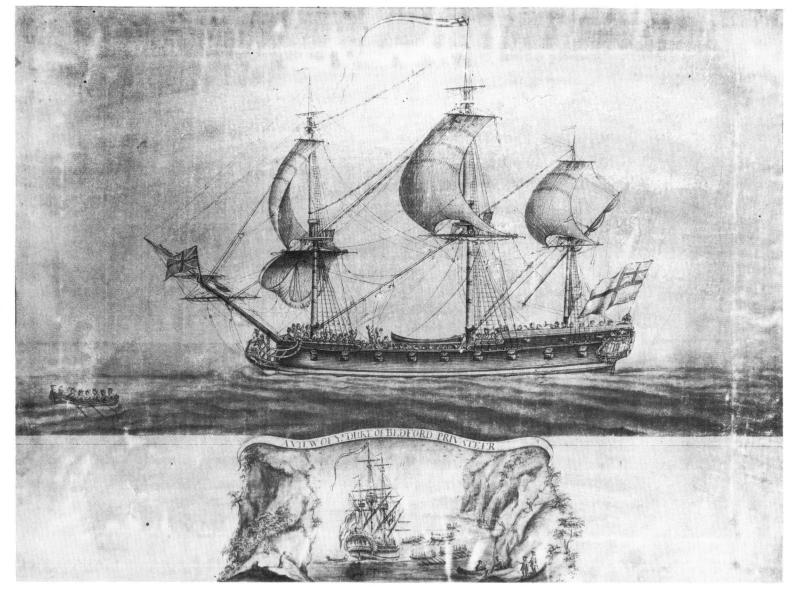

A VIEW OF ye DUKE OF BEDFORD PRIVATEER

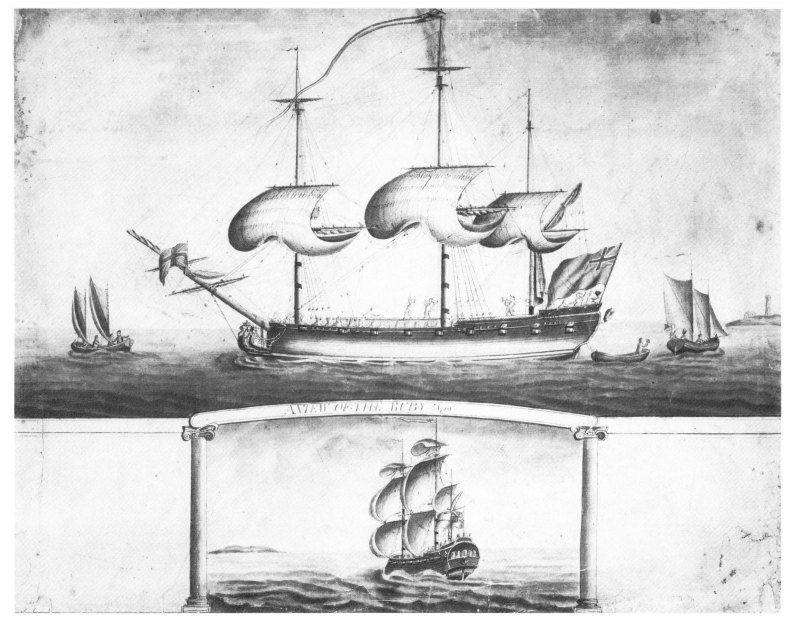

A VIEW OF THE RUBY 1749

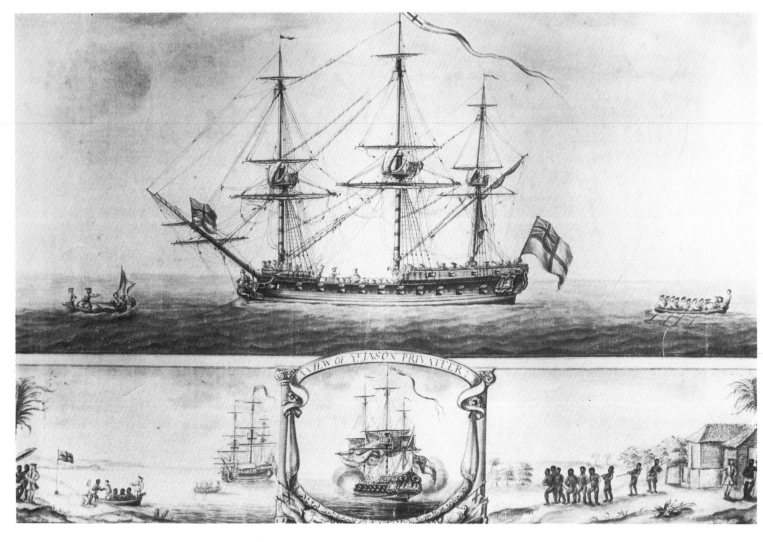

A VIEW OF YᵉJASON PRIVATEER

3 "A VIEW OF YE JASON PRIVATEER" *c.*1760

Pen and ink and wash, 16¼ x 24¼ in.
Inscribed as the title
City of Bristol Museum and Art Gallery

Built at Bayonne in France in 1747, the *Jason* was
presumably taken as a prize soon afterwards for she was a
Bristol privateer early in 1748, the last year of the War of
the Austrian Succession. She was then three hundred and
fifty tons, had thirty-two guns and carried two hundred
men. She was sold in 1749 when lying at Sea Mills Dock
on the Avon, the dock at which the *Southwell* had been
refitted in 1744.

Pocock depicts the *Jason* at anchor with all her sails
furled, presumably in purposeful contrast to the portrait
of the *Southwell*. Perhaps it is the pilot that is to be seen
arriving from the left and the commander from the right.

The drawing probably dates from towards the end of the
Seven Years War when privateers were often trading as
well as carrying Letters of Marque as privateers. The
detail in the drawings of the loading and taking of slaves
suggest that Pocock, himself, had first-hand experience of
the trade.

The *Jason* flies the White Ensign and the pennant, both
of which were more often the ensigns of the King's ships.
But Pocock depicts the pennant flying from the King's
ships, privateers and merchantmen alike. The White
Ensign he shows only on the King's ships and on
privateers. The holders of Letters of Marque may have
considered that they were in the King's service and
accordingly flew the White Ensign.

4 "THE SOUTHWELL FRIGATE" *c.*1760

Pen and ink and wash, 18⅛ x 21¾ in.
Inscribed as the title and twice: *TRADING ON YE
COAST OF AFRICA*
City of Bristol Museum and Art Gallery

This vessel, shown here with her full rig of twenty sails
unfurled, is the former privateer *Southwell*, one of the
finest and largest of the Bristol-owned ships, refitted for
privateering at the time of France's entry into the War of
the Austrian Succession (1739 – 48) in 1744. Her burden
was four hundred tons and she carried twenty-four nine
and six pounders, fourteen swivel guns and two hundred
men. She was first fitted out in London and brought in
eight prizes on her first cruise. It was at this time that a
report from Bristol said: 'Nothing is to be seen here but
rejoicings for the great number of French prizes brought
in. Our sailors are in the highest spirits, full of money,
carousing . . . dressed out with laced hats, tassels, swords
with sword knots, and in short all things that can give
them an opportunity to spend their money'. She was to
make several other cruises but her fifth and last major
cruise in 1746, for which the most detailed documents
survive in the Avon County Reference Library, brought
most of the seamen a return in prize money of only nine
shillings and seven pence.

By October 1746 the *Southwell* was employed as a slaver
but with a Letter of Marque. She arrived in Antigua with
three hundred and one slaves, one hundred and fifty
having been lost on the passage from Africa.

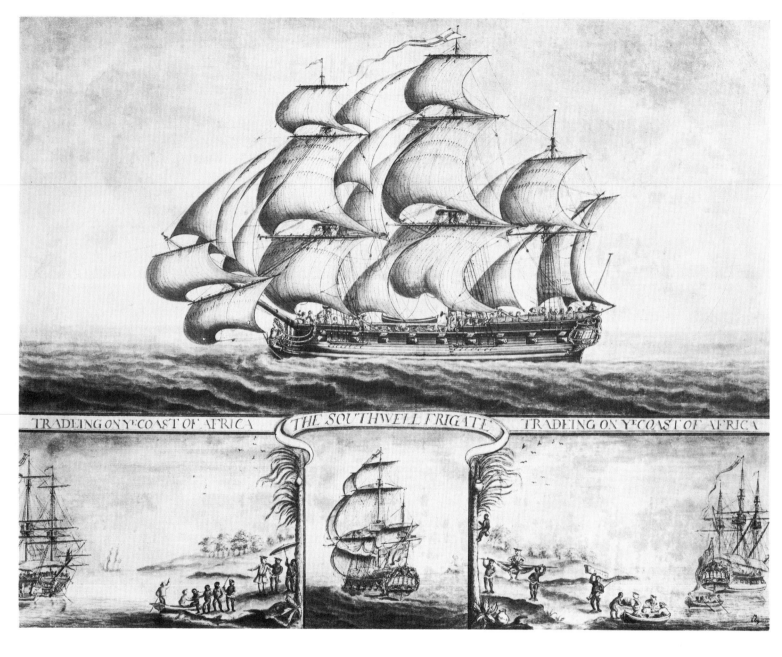

TRADEING ON Yᵉ COAST OF AFRICA · THE SOUTHWELL FRIGATE · TRADEING ON Yᵉ COAST OF AFRICA

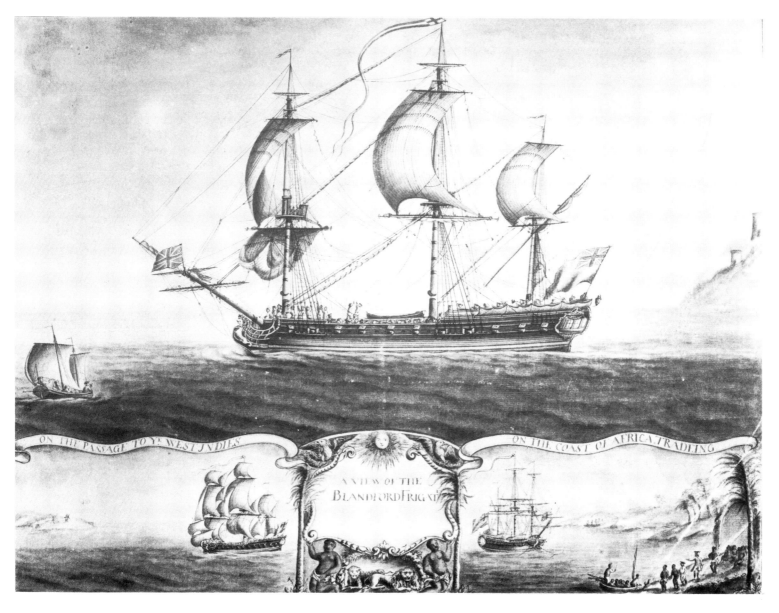

ON THE PASSAGE TO Y.e WEST INDIES

ON THE COAST OF AFRICA TRADING

A VIEW OF THE BLANDFORD FRIGATE

5 "A VIEW OF THE BLANDFORD FRIGATE" *c.*1760

Pen and ink and wash, 17 x 21½ in.
Inscribed as the title and: *ON THE PASSAGE TO YE WEST INDIES* and *ON THE COAST OF AFRICA TRADEING*
City of Bristol Museum and Art Gallery

The *Blandford,* a privateer of three hundred and eighty tons, twenty-six guns and two hundred and forty men was exceptionally successful during the War of the Austrian Succession (1739 – 48) and early in 1747 brought in a rich prize valued at £30,000. But her captain died from wounds received in the action and on her next cruise the *Blandford* was herself captured. She was presumably subsequently recaptured and is shown here, several years later, as a slaver.

6 Wapping, Bristol *c.*1760

Pen and ink and wash, 18 x 23 in.
City of Bristol Museum and Art Gallery

This drawing, one of the most expressive visual records of Bristol's long history of shipbuilding, has only recently been ascribed to Nicholas Pocock. It had previously been attributed to an anonymous artist with the initials 'S. T.' and the unsigned drawings of the *Southwell, Jason* and *Blandford* were duly added to the *oeuvre* of S. T. on comparative stylistic grounds. But the letters 'S. T.', which are carved into a log on the right-hand side of this scene, are the initials of Sydenham Teast, owner of the wet and dry docks depicted here. Four successive Sydneham Teasts built and refitted ships at Wapping from about 1750 until 1841. The second of the two docks shown here was to be gated in 1769.

In the centre of the lower right-hand vignette is St. Mary Redcliffe. Redcliffe Parade, which was a development by Sydenham Teast begun in 1768, has yet to be built. On the north side of the river is Padmore's Great Crane and on the south side, below the docks also depicted in the larger drawing, a ship is being launched from the eastern dock on Wapping, now the site of Prince's Wharf and the Bristol Industrial Museum.

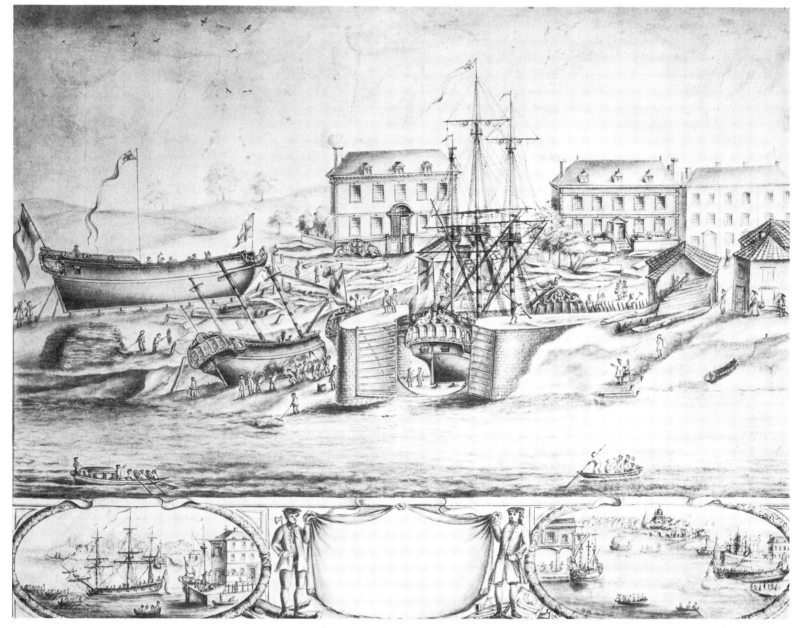

7 "A View of the SOUTH WEST SIDE OF THE HOUSE
OF THOMAS TYNDALL, Esq. At the FORT Near
BRISTOL" *c*.1762

Pen and ink and wash, bodycolour and watercolour,
14¾ x 19⅝ in.
Signed: *N. Pocock* and inscribed as the title
City of Bristol Museum and Art Gallery

The Royal Fort, now the property of the University of
Bristol, was completed in 1761 for Thomas Tyndall. The
architect was James Bridges and the superb interior stucco
decoration was by Thomas Paty. Pocock's drawing
presumably dates from within a very few years of the
building's completion.

The house is drawn in pen and ink and wash in a manner
similar to Pocock's other early drawings but the gouache
over-colouring of the trees, lawns, figures and animals has
led to the suggestion that another artist assisted Pocock.

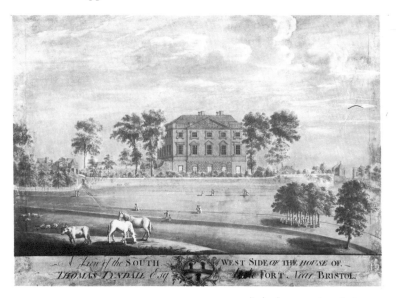

But it should be expected that Pocock, when doing an
early and unfamiliar portrait drawing of a country house,
would look closely at the work of the nearest
contemporary master of such scenes: Thomas Robins of
Bath.

8 "A view of a Ship of War clearing hawse & making the
SIGNAL to Unmoor" 1762

Pen and ink and wash, 6⅞ x 10 in.
Signed and dated: *Drawn by N. Pocock/Bristol Decr.
1762* and inscribed as the title
City of Bristol Museum and Art Gallery

This careful drawing, with much detailed observation of
the complex manoeuvre of unmooring a king's ship of
over sixty guns, has an assurance and relative fluency that
was quite absent in the dated portrait of the *Ruby* of 1758
(pl. 2). Its clearly inscribed date of 1762 allows the less-
accomplished and undated ship portraits and *View of
Wapping* (pl. 3 – 6) to be dated before 1762 on stylistic
grounds.

No dated drawing, apart from those in the logbooks, has
yet been identified between the date of this drawing of
1762 and the portrait of the *Cumberland* of 1778 (pl. 13),
when Pocock may have just ceased to be a mariner. In
these sixteen years there was to be very little development
of style.

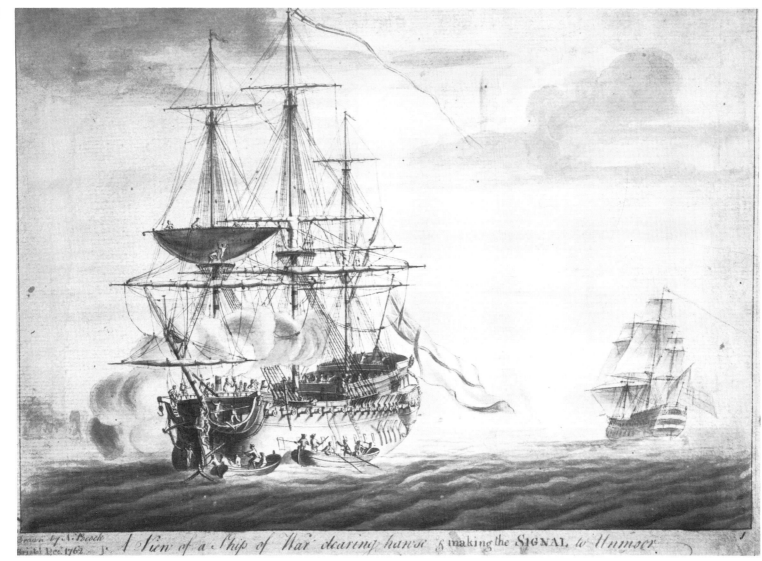

Drawn by N. Beck
Bristol Dec. 1768 — *A View of a Ship of War clearing hawse & making the SIGNAL to Unmoor.*

9 The frontispiece from the logbook of the ship *Lloyd*, 1771 – 2

"A Plain Chart of THE WESTERN OCEAN" showing *"THE TRACK of the Ship* Lloyd *from Bristol to Dominica and from thence to* LONDON *from Jany. 'till Sep 1771"* and from January until August 1772.

Pen and ink and wash, 12⅜ x 8 in.
Collection of the City of Bristol Record Office

This remarkable logbook is one of seven similar volumes covering twelve voyages made between 1767 and 1776 by Nicholas Pocock as captain of the ships *Lloyd* and *Betsey* and of the snow *Minerva*. Each voyage was made for the Bristol merchant, Richard Champion, and these logbooks were apparently made as gifts to him in recognition of Pocock's profound gratitude, esteem and friendship for his employer.

The first five voyages were made to Charleston in South Carolina, one voyage was made to Cork, Cadiz and Leghorn and the remainder were to Dominica and Nevis in the West Indies. Four of the logbooks are in the National Maritime Museum; one is in the Mariners' Museum, Newport, South Carolina; one is untraced; the present volume was purchased by the City of Bristol in 1982.

10 "A View of Montserrat from the North West" from the logbook of the ship *Lloyd*, 1771 – 2

Pen and ink and wash, 12⅜ x 8 in.
Signed: *N. Pocock* and inscribed as the title
Collection of the City of Bristol Record Office

This portrait of the ship *Lloyd* may have been drawn during the gentle weather covering much of the return journey from Dominica. Pocock had left Bristol on 8 January 1771 to arrive at Dominica on 16 February 1771. He remained in the Leeward Islands for five months leaving on 25 July and arriving in London on 10 October.

The *Lloyd* was named after the family name of Champion's wife. Richard Champion and Judith Lloyd had eloped to Edinburgh to marry in 1746.

11 Two pages from the logbook of the ship *Lloyd*, 1771 – 2

Pen and ink and wash, 12⅜ x 16 in.
Collection of the City of Bristol Record Office

Fresh breezes, light airs, and calms are depicted during the third week of the return from Dominica on the first of the two voyages recorded in this logbook.

Each of the small drawings are portraits of the *Lloyd* from different angles and according to conditions prevailing at some time during that day.

After arriving in London on 10 October, Pocock remained there until 15 November before sailing to Bristol laden with sugar, arriving on 25 November.

9

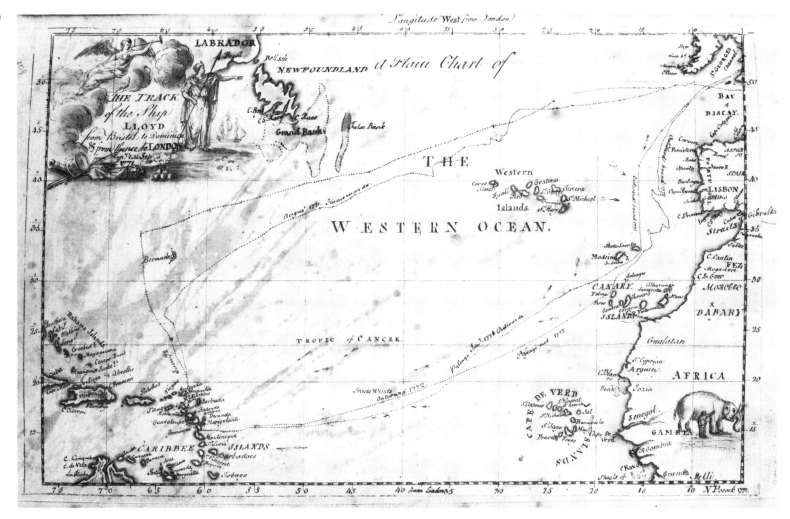

27

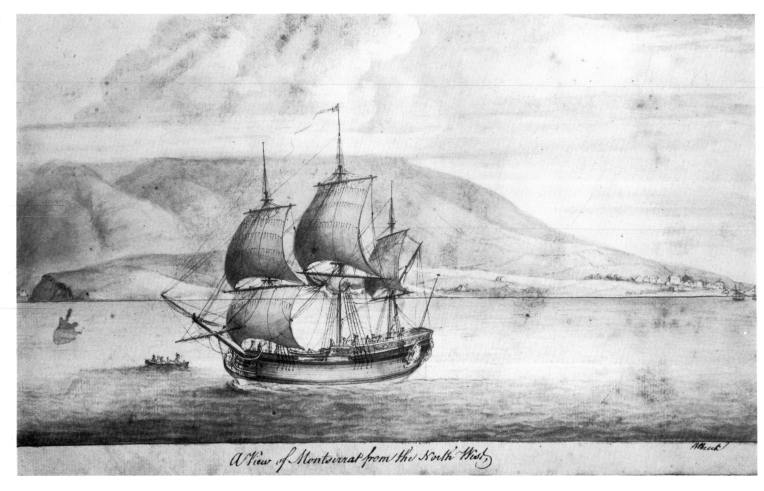

A View of Montserrat from the North West

From Dominica towards London, in the Ship Lloyd

Left page

Tuesday 6th August

Fresh Breezes & Cloudy all these 24 hours &c

H	K	K	Courses	Winds
2	4		North	E&E
4	4			
6	4			
8	4			
10	4	1		
12	4			
2	5		N&E	E&N
4	4			
6	4			
8	4			
10	3	1	North	E&E
12	3	1		

Course	N.W.
Dis	93
Lat	91 North
Depart	18 West
Long in	20 d
Long in	63-21
M.D	28 d
L.M	30

Latt.d Observ'd 24. 4 North

Wednesday August 7th 1771

Light airs, with Pleasant Weather &c

H	K	K	Courses	Winds
2	3	1	North	E&E
4	4			
6	4		N&W	N&E
8	4		No	E&E
10	3			
12	2	1	N&W	
2	2			
4	2			
6	2	1		
8	3		N.W&N	
10	2		N&W	
12	2			

Course	N.N.W
Dis	70
Lat	65 North
Dep	26 West
Long	29 d
Long in	63-31
m.D	54
L.M	59

Latt.d Observ'd 25. 9

Thursday August 8th 1771

Very light airs with fair Wr Swell from the South East for which I allow —

H	K	K	Courses	Winds
2	1	1	N&W	N&E
4	1	1		
6	1	1		
8	1			
10	1		N&W	
12	1			
2	1		N&E	
4	1			
6	1		North	E&E
8	1			
10	1			
12	1			

Course	North
Dist	37
Lat	34 North
Depart	14 West
Long	16 d
Long in	63-47
m.D	69
L.M	75

Latt.d Observ'd 25. 43

Right page

Friday 9th August 1771

All these 24 hours Calm, with a Swell from Y.E.d

H	K	K	Courses	Winds
2			Calm and Foggy	N.o
4				
6				
8				
10				
12				

Course	N.o
Dis	13
Lat	13 d
Dep	00
Long	00
Long in	63-47W
M.D	68
L.M	75

Lattitude Observ'd 25.56

Saturday 10th August 1771

The first part Calm, the Middle & latter parts Light airs, with pleasant weather smooth water & Foggy, a Sloop in sight St.d to the Southward

H	K	K	Courses	Winds
2			Calm	
4				
6				
8				
10	1		N.N.W	North
12	2			
2	2	1	N.N.W	N&E
4	2			
6	2		N.N.W	N.E&N
8	2	1		
10	2	1	N.N.W	N.E
12	2	1		

Course	N.W
Dist	34
Lat	24 North
Depart	24 West
Long	27 d
Long in	64-14 d
M.D	92
L.M	102

Latt.d Observ'd 26. 20 North

Sunday 11th August 1771

Light airs Variable, with some Showers rain

H	K	K	Courses	Winds
2	2		N.N.W	N.E&N
4	1	1		
6	1	1	N.N.W	N&E
8	2			
10	2		N.N.W	N.E&N
12	2			
2	2		North	E&N
4	2	1		
6	2	1	N.N.E	East
8	2	1		
10	4		N.E	E&N
12	3		N&E	

Course	N. 15 West
Distance	49
Lat	47 North
Depart	12 West
Long	14 d
Long in	64-28 d
m.D	104 d
L.M	116 d

Latt.d by Observation 27.5

12 Two pages from the logbook of the ship *Lloyd*, 1771 – 2

Pen and ink and wash, 12⅜ x 16 in.
Collection of the City of Bristol Record Office

On the outward journey of the second of the two voyages recorded in this logbook, Pocock encountered severe gales south-west of Portugal. The erratic course that resulted is clearly shown on the map at the beginning of the logbook (pl. 9). For Wednesday, 29 January, the second of the days shown on these pages, Pocock records: '. . . very hard Gales with constant Rain and a Great head Sea, Shipped a deal of water' and on the following days he records: '. . . it has blown a Storm of Wind, with a lofty Dangerous sea running Ship'd a Great Quantity of Water . . .', '. . . very strong gales with thunder lightning Hail and Rain. A Great head Sea.' and '. . . very strong Gales and Squally, with Thunder and lightning . . .'. Further gales and vicious squalls were to follow and the foretopmast was lost.

A week after arriving in Dominica, Pocock wrote to Richard Champion: 'The pleasure I feel in having an opportunity of writing, you know; it bears a proportion to the distress of separation. I had scarce taken the last view of Lundy plagued with a drunken mutinous crew and a depression of spirits custom has never been able to assist in curing, ere I was overtaken by a violent storm, which I was afraid would have forced me back again. We continued bad weather for three weeks'.

On this second voyage, the *Lloyd* had left Bristol on 21 January to arrive on 2 March. Pocock remained three and a half months in the islands, departing on 19 June and arriving in London on 1 August.

The Muster Roll for this voyage was copied by Pocock into the last page of this logbook. It lists fourteen crew members including the captain. Below Nicholas Pocock's name is that of Isaac Pocock, his youngest brother. In 1775 Isaac was to be captain of the *Aurora* and in 1776 of Richard Champion's ship the *Marquis of Rockingham* when it was captured by the *Sturdy Beggar* of Maryland at the outset of the American War of Independence (1775 – 83). Another brother, William Innes Pocock, had earlier accompanied Nicholas on the *Lloyd* on a voyage to Charleston in 1768. In 1776 he was captain of Richard Champion's snow *Champion*.

From Bristol towards. Dominica in the Ship Lloyd.

Left page

H	K	HK	Course	Winds	Tuesday January 28.th 1772
2	6		SW	NE	The first and Middle Parts Squally, Variable
4	6	1			with Rain, the Latter fresh Breeze & Cloudy
6	6	1		North	a large Swell from the N.W. P.M. Saw Sail.
8	6				
10	4	1			
12	4	1		NNW	
2	4			Variable	
4	3	1	SSW		
6	3	1	SW	WSW	
8	3	1	SSW	West	
10	3	1	SSE	SW	
12	3		NE½E	SW	

Course	S.B.W.
Dist	108
Xlatt	107 South
Dep	7 West
Long	13 a
Long in	15 14 W
M. D	1530 a
L. M.	10. 34 a

Latt.d Observ'd 39. 5. North

H	K	HK	Courses	Winds	Wednesday January 29.th 1772
2	4	1	SbE	SW	At 6 P.M. in 1st R.S. down Main Topsl Yard
4	4	1	West	SSW	at 8 in all R.S. Hand F.&. Mizen &. at 9 Handed Main
6	3	1	WSW	South	&. 2 A.M. down fore & Mizen Staysails Blows a Storm
8	4				The first part fresh Gales and Cloudy the Middle
10	3				and latter very hard Gales with constant Rain
12	2	1			and a great head Sea, Ship's a deal of Water
2	3				Current N
4	3				
6	3	1			
8	2	1	WNW	NNW	
10	2	1	WNW	SW	
12	2	1	WbS	SWbW	

Course	S. 52 W.
Dist	59
Xlatt	36 South
Dep	38 West
Along	48 a
Long in	16. 2 W
M. D	468 a
L. M.	11. 22 a

Latt.d P Account 38. 35

H	K	HK	Courses	Winds	Thursday January 30.th 1772.
2	2	1	WSW	SW	The first and Middle parts of these 24 hours short sea
4	2	1			a stern Wind with a lofty Dangerous Running Ship'd
6	2	1			Quantities of Water, the Latter p. Mod.te Saw Several Sail
8		up SW	off NNW		
10					
12		up NNW	off SSW		
2					
4		up N.	NSbE		
6	2	1	SW	SW	
8	3		SE. S		
10	3	1			
12	2	1	SSW E So Saya		

Course	Stewart
Dist	22
Xlatt	9 South
Dep	14 West
Along	18 a
Long in	16. 93
M. D	48 2
L. M.	11. 4

Latt.d Observ'd 38. 26. North

Right page

H	K	HK	Courses	Winds	Friday January 31.st 1772.
2	3	1	SSE	SW	at 5 P.M. down F&. Maintopsl Stays at 8 hand & spread
4	4		SSW	W	The first part fresh Gales the Middle & Latter very Strong
6	3		South	WSW	Gales with Thunder, Lightning & Rain a great head Sea
8	4		SE		
10	2				
12	2		South	WSW	
2	2		SWbS	WbN	
4	2	1	SW	West	
6	3		WbS	WbN	
8	3	7			
10	2				
12	2	1	SSW	West	

Course	SB¾W
Dist	75
Xlatt	68 South
Depart	32 East
Along	40 a
Long in	15. 10 West
M. D	450 a
L. M.	11. 00 a

Latt.d Observ'd 37. 18 North

H	K	HK	Courses	Winds	Saturday February the 1.st 1772
2	2		SW	West	The first and Middle parts of these 24 hours strong gales
4	2	1	SbW	WbS	Squally with Thunder & Lightning in all 2d at half day
6	1		SW	West	Past, the latter more Mod.te at 8 P.M. SW M.st F Topsails
8	1		SWbW	WNW	
10	2		SW	West	
12	2	1	WbS	WbS	
2	2		WSW	WSW	
4	2	1			
6					
8					
10	3		SW	WNW	
12	3				

Course	S. 30 E
Dist	80 Miles
Xlatt	69 South
Dep	40 East
Along	50 a
Long in	14. 50 West
M. D	490 a
L. M.	10. 10 a

Latt.d Observ'd 36. 9 North.

H	K	HK	Courses	Winds	Sunday February 2.d 1772.
2	3		SW	WNW	The first part fresh Gales with Fair Weather, the
4	4	1	Qus?RS		Middle and Latter light Breezes Variable with
6		SWbS	WbS	Cloudy Weather at 11 P.M. Lost Ship Small Rain	
8	3	1	SWbW	WNW	
10	2		SW	WSW	
12	2				
2	2	1	SWbS	WSW	
4	2	1	SW	West	
6	2		South	WSW	
8	2			WbS	
10	3		SSW	West	
12	1	1	WSW	W	

Course	S. ...
Distance	62
Xlatt	62 South
Depart	2 East
Along	2 a
Long in	14. 48 West
M. D	408 a
L. M.	10. 6 a

Latt.d P Account 35. 7

13 "A VIEW OF THE SHIP CUMBERLAND" 1778

Pen and ink and wash, 13¾ x 19 in.
Signed and dated *N. Pocock 1778* and inscribed as the title
City of Bristol Museum and Art Gallery

In 1776 and 1777, the *Cumberland* sailed to Dominica, Honduras and St. Kitts. In December 1777 she departed for Jamaica, and Pocock may have drawn her portrait on her return in November of the following year. In 1779 the *Cumberland* was wrecked off the island of St. Pierre, Newfoundland, *en route* for Quebec.

In this ship portrait the crew are to be seen hauling in the anchor. The merchantman is off Flatholm island whose lighthouse was first kindled in 1738. The ship on the right is the same ship and Pocock was following a common practice in depicting the vessel two or three times within the same picture.

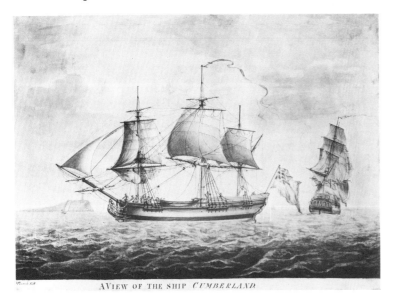

A VIEW OF THE SHIP *CUMBERLAND*

14 "HIS MAJESTY'S FRIGATE ARETHUSA of forty Guns. Built at BRISTOL by Mr. James Hilhouse 1781"

Pen and ink and watercolour, 18¾ x 25⅛ in.
Inscribed as the title
City of Bristol Museum and Art Gallery

The *Arethusa*, of nearly one thousand tons, was launched in April 1781 and was then the largest vessel ever to have been built in Bristol. She was to enjoy most distinguished service and deserves to be one of Bristol's most celebrated ships. James Martin Hilhouse, had first received a commission from the Admiralty to build a king's frigate in 1778 and the *Arethusa* was the fifth such ship that he had built. War broke out with the American colonies in 1775 and in 1778 France joined forces against Great Britain, followed by Spain and Holland in 1780.

The *Arethusa's* first commander was to be Captain Sir Richard Pearson. In September 1779 Pearson had captained the *Serapis,* a newly-built frigate of forty-four guns. Off Flamborough Head, within sight of a large crowd he had been obliged to surrender to the famous American, John Paul Jones, who was in an elderly refitted East Indiaman of forty guns, It was one of the bloodiest and most ignominious engagements of the war. Pearson was exonerated in the subsequent court martial and actually knighted by the King.

This drawing was owned by Abraham Hilhouse, and was almost certainly commissioned by his father, J. M. Hilhouse, the *Arethusa's* builder. Pocock exhibited it at the Royal Academy in 1782, the first year at which he had exhibited there, together with two other watercolours of St. Mary Redcliffe and Clifton Wood (pl. 16, 17) and an oil painting.

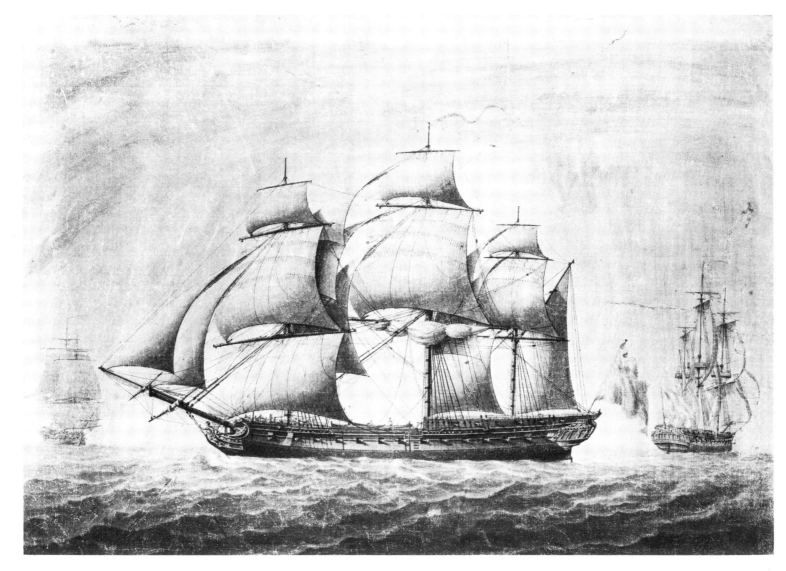

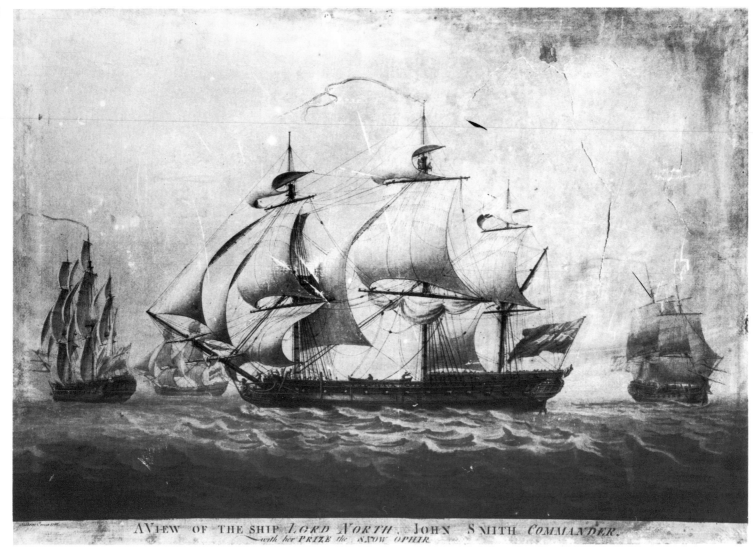

A VIEW OF THE SHIP *LORD NORTH*, JOHN SMITH *COMMANDER*,
with her *PRIZE the SNOW OPHIR*.

Before conservation. *See page 9*

15 "A VIEW OF THE SHIP LORD NORTH, JOHN SMITH COMMANDER. with her Prize the Snow OPHIR" 1782

Pen and ink and watercolour, 17¼ x 24½ in.
Signed and dated: *Nicholas Pocock 1782* and inscribed as the title
Private collection, Bristol

This fine portrait was doubtless commissioned by the ship's captain, and remains in the family of his descendants. It is a triple portrait with the prize depicted in the distance. A Letter of Marque was issued for the *Lord North* in 1779 and in 1781 when John Smith was in command.

Captain John Smith's Bible survives and it most diligently records each church service he attended and the text of every sermon he heard. It also includes this, his own prayer:

> *The Lord North, God Almighty Keep*
> *From Powerfull Foe's and Danger's Deep,*
> *From Rock's and Sand's of Every Sort—*
> *Return us safe to our Desir'd Port.*
> *And if Success He Doe's Bestow*
> *The Lord be praised for it Also.*

Some success did come to Captain Smith, for it was reported that in January 1783, the *Lord North* together with five other West Indiamen had taken a Spanish prize. In September of the same year he was married at Temple Church, Bristol, at the age of forty-four. His Bible includes shorter prayers for his subsequent commands of the *Good Hope* (1785), the *Jupiter* (1790) and the *Lion*.

16 A view from Sea Banks towards St. Mary Redcliffe 1781

Pencil, pen and ink and watercolour, 14⅛ x 21⅛ in.
Signed and dated on original mount: *Nicholas Pocock 1781*
Collection of Spink and Son Ltd.

This ambitious drawing, the earliest of Pocock's large Bristol scenes after ceasing to be a ship's captain, was shown at the Royal Academy with two other watercolours in 1782 (pl. 14, 17).

The ship being built on the right is possibly the King's ship, the *Hermione*, built by Sydenham Teast and launched from Wapping in September 1782. Over twenty years have passed since Pocock's first drawing of this scene (pl. 6). Both the docks are now gated and above them the west end of Sydenham Teast's development of Redcliffe Parade, built in the 1770s, is complete. On the left is The Grove and John Padmore's Great Crane, erected in 1735.

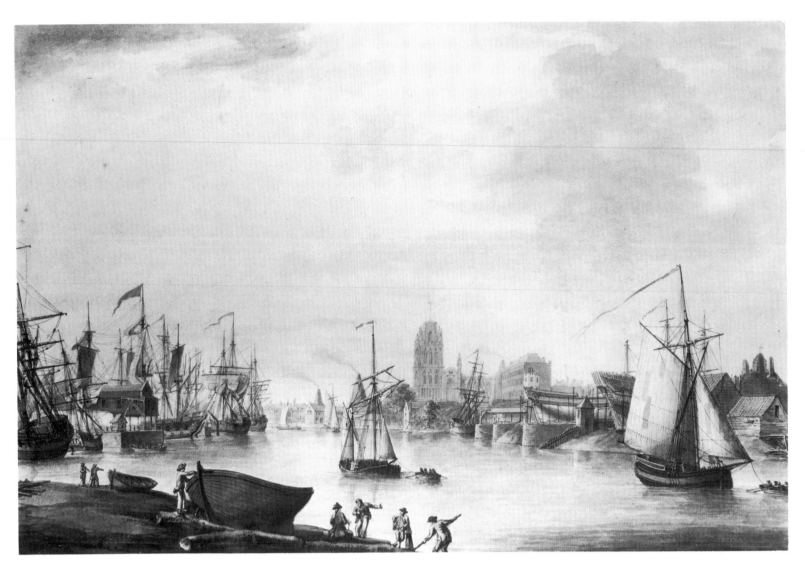

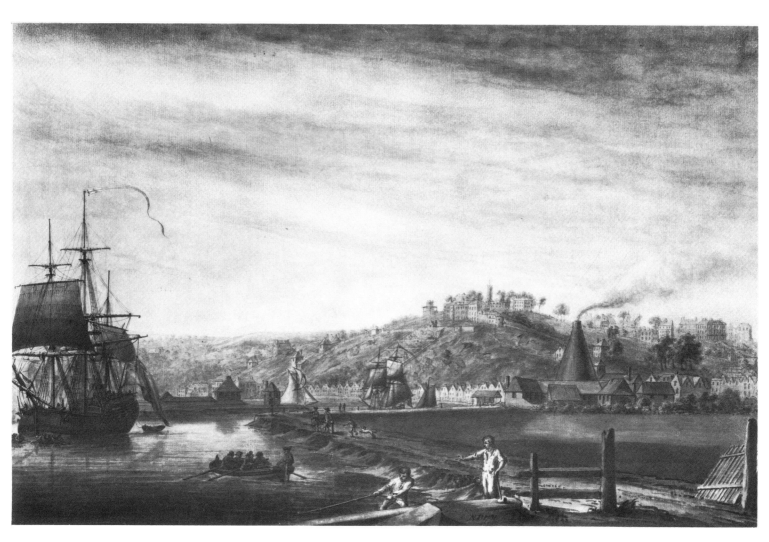

17 **View of Clifton Wood from Sea Banks** 1781

Pencil, pen and ink, watercolour and bodycolour,
12¾ x 19¾ in.
Signed and dated: *NP 1781*
Private collection, Bristol

Sea Banks, the meadow in the foreground bordering on
Canons' Marsh, was soon to be developed for boat
building. The large glass-house at the bottom of Jacobs
Wells Road and Limekiln Lane was known as Childs Glass
House. Immediately beyond it was Limekiln Dock, not
visible in this view, which was a dock of seventeenth-
century origin that continued in use until the early years
of this century.

Above the glass-house many of the Georgian houses still
survive today. Most obvious are Thomas Goldney's
colonnaded rotunda and his tower, built in 1764 to house
a steam-engine to pump water to the grotto and fountains
of his fine garden. The largest house to the right is
Clifton Hill House completed in 1750 to the design of
Isaac Ware.

18 **The Avon with Clifton Wood and Bristol Cathedral**
c.1785

Pencil and watercolour, 16½ x 24 in.
Collection of J. C. G. Hill, Esq.

On the immediate left is the edge of Rownham Meads,
meadows that were to be dug out for the creation of
Cumberland Basin at the construction of the Floating
Harbour, 1804 – 9. Beyond is the entrance to Merchants
Dock, built in the 1760s by William Champion and filled
in two hundred years later. The two ships under
construction are in the yards adjoining the docks of
Noble, Farr and Champion and of J. M. Hilhouse.

By the date of this drawing, about 1785, Hilhouse was
well established as Bristol's leading shipbuilder. By now
he had probably taken over Noble, Farr and Champion's
yard and such was the number of orders from the
Admiralty for men-of-war that he had opened Red Clift
Yard, on the extreme right of this view, in 1780. Before
his orders from the Admiralty ceased and the yard closed
in 1786, he built there the King's frigates: *Termagant*,
Diomede, *Serapis*, *Nassau* and *Melampus*. The ship on
the stocks could be one of these. No other visual record of
the Red Clift Yard is known.

18

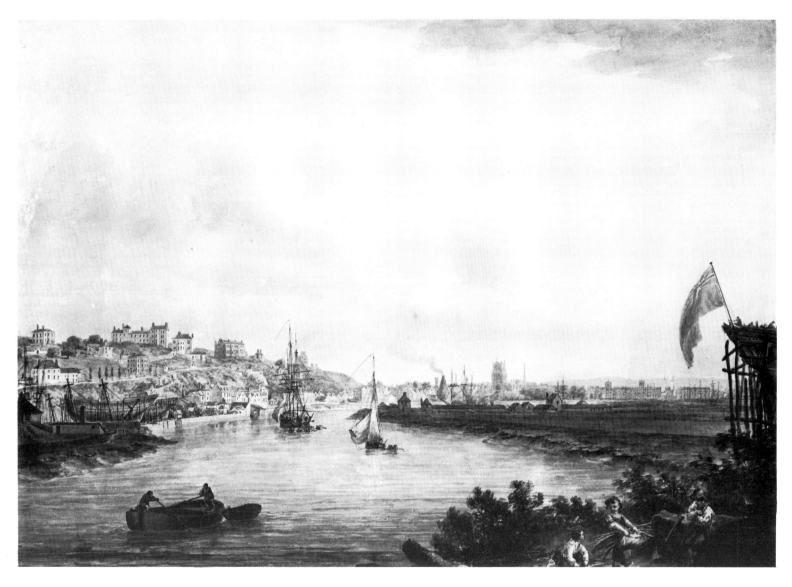

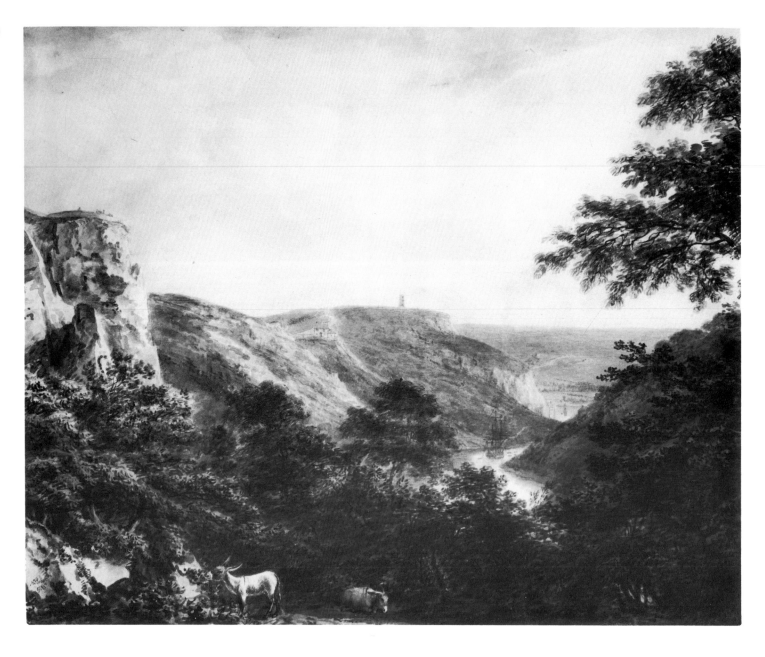

19 The Avon Gorge from below Cook's Folly 1786

Watercolour, 16 x 20¼ in.
Signed and dated: *N Pocock 1786*
Private collection, Bristol

This drawing is perhaps the most attractive and almost
certainly the best preserved of Pocock's many large and
more rustic landscape views. On the left are the cliffs
known as Sea Walls, a name which the historian,
Latimer, suggests derives from the wall built by John
Wallis in 1746 to end the fatalities amongst the
perambulating public. A horse and carriage can be seen
above the wall and it was clearly as popular a vantage
point in the eighteenth century as it is now.

The cottage to the left of the ruined windmill on Clifton
Hill was the gatehouse of the Clifton Turnpike.

**20 The Avon Gorge from above Paradise Bottom, Leigh
Woods, looking upstream 1784**

Watercolour, 15¾ x 22¾ in.
Signed and dated: *N Pocock 1784*
Private collection, Bristol

On the left is Cook's Folly, built as a summerhouse in
1696. The scale of Wallis's wall, beyond, is clearly seen
and in the far distance is the signal staff or semaphore,
apparently still operable at this time.

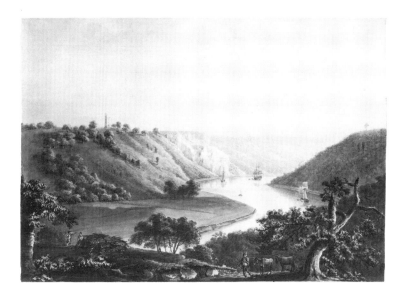

21 View over Kingsweston towards the Bristol Channel

*c.*1785

Watercolour, 17¼ x 25⅝ in.
City of Bristol Museum and Art Gallery

Pocock's series of large watercolours (pl. 16 – 21) of views on the Avon concludes with the most successful of them all. The foreground trees, entwined in elegant conversation, best suggest the maturity and sophistication that his drawing had aquired since the earliest of the sequence. It is the work of a confident and established artist.

In the centre of this scene are the stables to Vanburgh's Kingsweston House, and beyond the house is the tower of the eye-catching gateway that had no functional purpose. Near the mouth of the Avon ships are awaiting a favourable wind and tide. Beyond is Portishead Point.

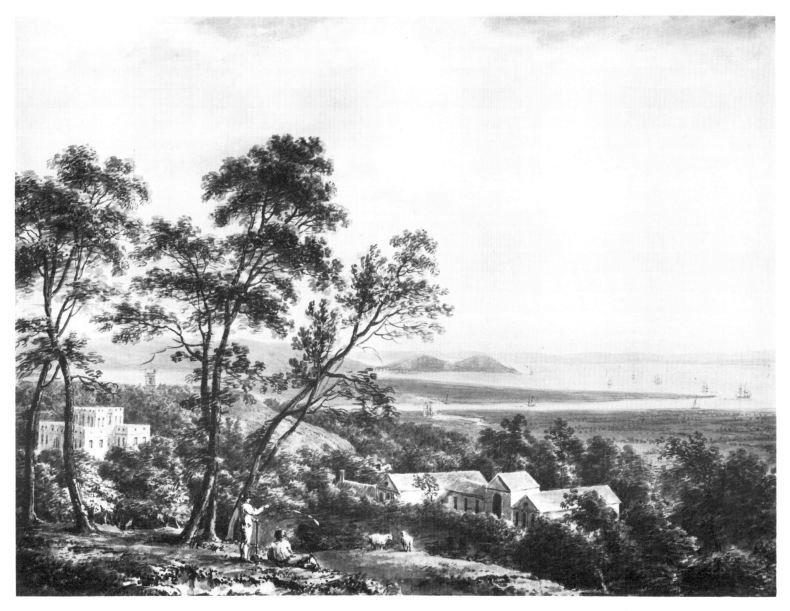

22 – 29 Pocock's engraved views on the Avon

During the 1780s and for twenty years afterwards, Pocock produced impressions of eight etched and sometimes aquatinted views. They were not really a set but a series, produced in varying groups over a long period. The etched outline was extremely slight and is often confused with pen and ink. The watercolour that Pocock himself added is painted with exemplary care.

The earliest dated etching in the City of Bristol Museum and Art Gallery's collection is inscribed 1781, and is an impression of the view of Clifton Hill. There are other versions of this view and of both the Hotwell and the Cathedral, which are dated 1782. From 1786 versions appear with aquatint added to assist the modelling and shading. This printed base can be very much more obvious but it was still Pocock himself who added the watercolour. A number of impressions of the engravings (pl. 22, 24) do exist without watercolour and one etching, with the watercolour added by a different and incompetent hand, is known. The latest dated impression amongst the engravings in the Museum and Art Gallery's collection is inscribed 1801.

In the National Maritime Museum there is an album bearing the book-plate of William Innes Pocock, Nicholas's third son, containing ten engraved views on the Avon. Two of these are probably William's own additions to his father's series of eight prints.

The following examples of the engravings have been chosen to illustrate Nicholas Pocock's technique and the variety and range of the impressions that can occur.

22 Bristol Cathedral and the Quay from Wapping

Etching, 10 x 15³⁄₁₆ in. (image)
Inscribed in the plate: *Published by N. Pocock, Princes Street, Bristol decr 31 1782*
City of Bristol Museum and Art Gallery

It is possible that this rare example of an untinted etching was not coloured because the plate had been over-inked and the lines would have stood out too strongly from the watercolour.

23 St. Mary Redcliffe from Sea Banks, Bristol

Etching and watercolour, 9⅝ x 14½ in. (image)
City of Bristol Museum and Art Gallery

This engraving is based upon Pocock's watercolour of 1781 (pl. 16). He has subtly narrowed and fore-shortened the view, much improving the composition.

24 Clifton Hill from Sea Banks

Etching and aquatint, 10 x 15 in. (image)
City of Bristol Museum and Art Gallery

This untinted aquatint may also have survived uncoloured because it was too dark an impression for the successful addition of watercolour.

25 The Hotwell

Etching, aquatint and watercolour, 9½ x 14¾ in.
(image)
Signed and dated: *N. Pocock 1791*
Ashmolean Museum, Oxford

The Hotwell House itself was built in 1696 to provide a
pump-room over the spring which issued from the mud
twenty-six feet below high water at a temperature of
76 °F. Part of the colonnade and also Rock House at the
southern end survive today. The simple curved colonnade,
built for the benefit of visitors in bad weather, is usually
dated to the year 1786. However, it appears in unaltered
impressions of this engraving that bear the date 1782.

**26 "A VIEW OF THE HOTWELL By Nich.s Pocock
Bristol 1782"**

Etching and watercolour, 9¾ x 14⅞ in. (image)
Signed and dated: *N Pocock 1782 No. 2* and inscribed as
the title
City of Bristol Museum and Art Gallery

On the left a lime-kiln is in operation below St. Vincent's
Rocks.

**27 Avon Gorge with Cook's Folly from near the New
Hotwell**

Etching, aquatint and watercolour, 10 x 15 in. (image)
Signed and dated: *NP. 1787*
City of Bristol Museum and Art Gallery

An impression without aquatint, dated 1791, in the
Ashmolean Museum makes it clear that the addition of
aquatint, which first occurred in 1786, was not invariable
thereafter.

In 1786 Pocock exhibited a *View from the new Hot Wells:
a drawing* at the Royal Academy which may well be the
original but unlocated watercolour for this engraving.

The New Hotwell was open with varying success from the
1740s to the 1780s. In 1754 John Wesley was delighted
that it was 'free from noise and hurry' unlike the Hotwell
itself. But despite attempts to put Wesley's brief
patronage to good effect, the spa was far too difficult of
access to enjoy any real success.

28 View of the Avon and Bristol Channel

Etching, aquatint and watercolour, 9¾ x 15 in. (image)
Signed and dated: *N Pocock 1787*
City of Bristol Museum and Art Gallery

29 Kingsweston and the Bristol Channel

Etching, aquatint and watercolour, 10 x 14⅘ in. (image)
Signed and dated: *N. Pocock 1795*
City of Bristol Museum and Art Gallery

Amongst some of the later impressions there is evidence of
haste, and the aquatinted modelling is inclined to be
heavier in tone.

22

24

23

25

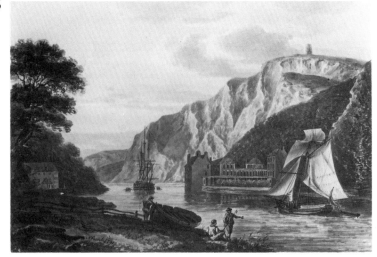

26

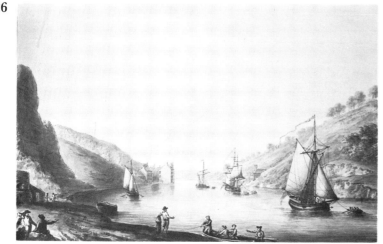

28

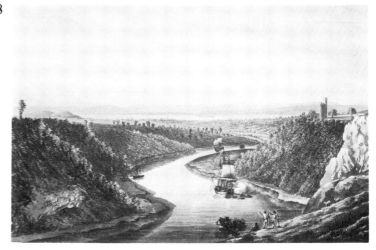

27

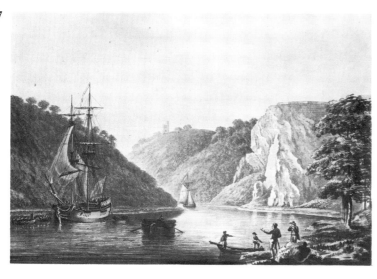

29

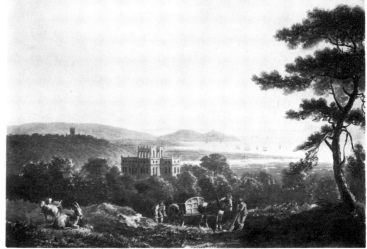

30 View over Kingsweston to the Bristol Channel at sunset

*c.*1785

Watercolour and pencil, 6½ x 9¼ in.
City of Bristol Museum and Art Gallery

As little known as Pocock's very early ship portraits, are
the series of slight sketches made along the Avon from
Bristol to Kingsweston. Many are drawn with great
fluency, with broad and simple washes of colour. From a
restricted palette, distinctive effects of light are realised
and it is possible that some of these drawings were
executed entirely on the spot.

31 The Bristol Channel from near Kingsweston

*c.*1785

Pencil and watercolour, 7¼ x 10½ in.
City of Bristol Museum and Art Gallery

Like the previous drawing, this sketch shows the entrance
to the Avon with Portishead Point and the Welsh hills
beyond. It also shows, most unusually, the island at the
entrance to the Avon, known as Dumball Island, which
was covered at high tide. Beyond it the ships are at
anchor in Kingroad awaiting the tide.

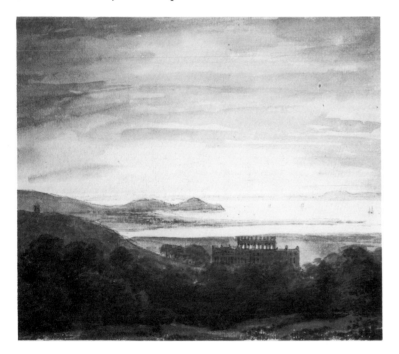

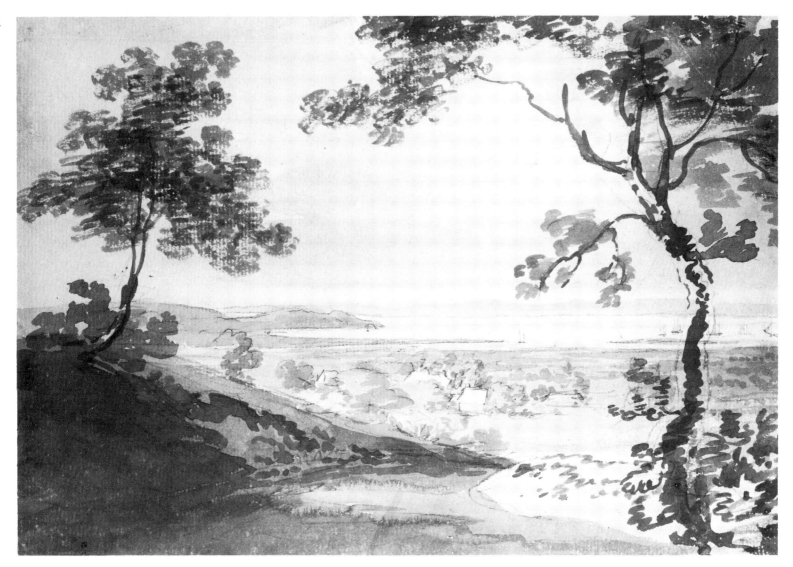

32 Studies of Hollyhocks *c.*1787

Pencil and watercolour, 9⅜ x 5⅝ in.
City of Bristol Museum and Art Gallery

This drawing comes from a scrapbook of sketches, one of which is dated 1787. Pocock was to produce a large number of informal sketches, some made as studies for use in larger finished watercolours and others, such as this, done apparently only out of affection for the subject and of delight in the handling of watercolour.

33 Study of an oak *c.*1787

Watercolour, 13¼ x 8½ in.
City of Bristol Museum and Art Gallery

34 Study of a tree and two donkeys

Pencil and watercolour, 9⅜ x 6¾ in.
City of Bristol Museum and Art Gallery

A similar study was probably used for the donkeys in the large *View of the Avon Gorge* (pl. 19).

33

34

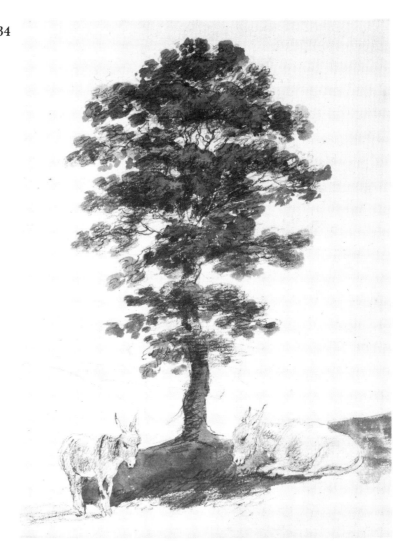

35 "Wreck of the Hanover Planter in Bristol River"

*c.*1785

Pencil and watercolour, 11⅕ x 18³⁄₁₀ in.
Inscribed as the title
City of Bristol Museum and Art Gallery

This leaf from a sketchbook demonstrates the hazards of navigating the Avon Gorge. In 1867 the *Bristol Times and Mirror* (16 March) noted that preparations were being made to blast the rock away 'at what is called the Hanover Planter Teahouse, a point of the bank so named from a West Indianman which some sixty or seventy years ago, was wrecked there and obliged to be broken up'.

A Letter of Marque was issued to a *Hanover Planter* in 1756 but the vessel shown here was probably a different ship of the same name launched in 1765. Grahame Farr, in *Shipbuilding in the Port of Bristol* (1977), notes an incorrectly recorded date of 1785 for the building of this

vessel. This date could well refer to the year of the wreck, however.

The ruined windmill, now the Clifton Observatory, can just be seen above St. Vincent's Rocks in the distance.

36 The Avon looking upstream from Kingsweston Down showing Cook's Folly, Sea Mills and Dundry *c.*1785

Watercolour, 5½ x 7¼ in.
Signed: *N Pocock*
Collection of Professor and Mrs T. F. Hewer

Just to the left of the centre of this drawing is a small terrace of houses, near which was Sea Mills Dock built early in the eighteenth century. Here the *Southwell* was refitted in 1744 and from here the *Jason* was sold in 1749 (pl. 3, 4). In the 1750s the dock was much used by whaling ships. By the 1770s the dock had been abandoned and no masts mark its position in this view which probably dates from the mid-1780s.

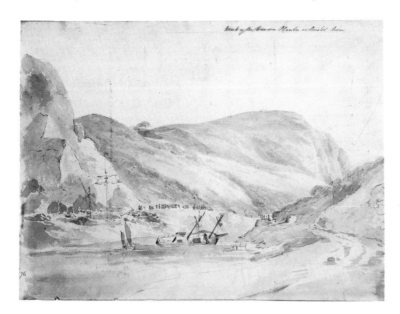

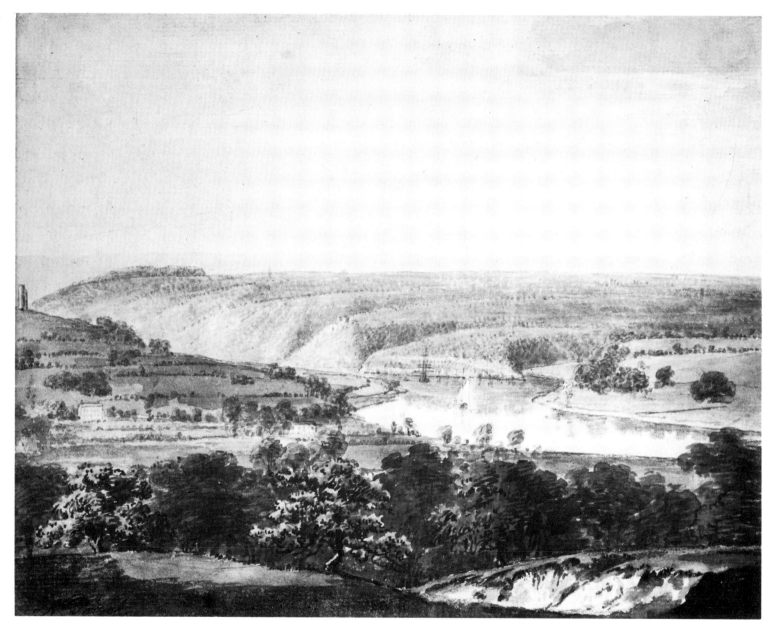

Watercolour, 16¾ x 22⅞ in.
Signed and dated: *N Pocock 1787 Decr.*
City of Bristol Museum and Art Gallery

Pocock produced variants of this view in both watercolour
and oils. The watercolour is dated 1788 and the oil 1789.
Such repetition is certainly a sign of success and Pocock's
move to London in 1789 is hardly a surprise. In 1788
Pocock exhibited a watercolour entitled *Portishead Point*
at the Royal Academy which is probably this drawing.

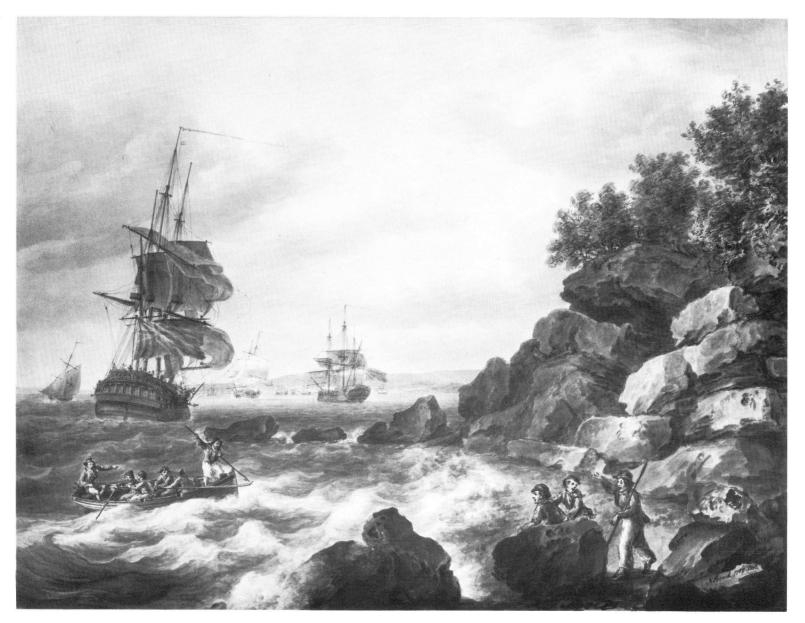

38 The Battle of the Saints, breaking the line *c.1782*

Oil on canvas, 41 x 65 in.
Signed: *J. M. Hilhouse*
Private collection

This painting and its companion (pl. 39) are almost certainly the joint products of two men—James Martin Hilhouse, Bristol's outstanding shipbuilder of the eighteenth century and Nicholas Pocock.

There is no technical reason for rejecting the authenticity of Hilhouse's signature on this work. Furthermore in 1865 the *Private Journal or Account Book of Charles Hill, 1859–1872* records the purchase of one picture of the Battle of the Saints 'by the late J. M. H.' and of 'the *Arethusa* by Pocock of Bristol' (pl. 14) from Abraham Hilhouse. Family tradition very clearly ascribed the painting to J. M. Hilhouse. Although only one painting is mentioned in the journal, the companion to this picture (pl. 39), depicting the close of this great battle, is certainly by the same hand and was also in the possession of a descendant of Charles Hill until very recently.

Hilhouse was a very fine naval draughtsman and Charles Hill & Son Ltd. have recently presented to the Museum and Art Gallery sixteen of his drawings. Several of these relate so closely to some of the vessels in the two paintings that they must have been employed in their composition. But no other oil paintings by Hilhouse are known and the drawings, however good they may be in the eyes of a naval architect or engineer, suggest no special painterly ability. Both paintings are not only very close in style to Pocock, they are also far too proficient in technique for an artist of no known experience in the medium, It seems likely, therefore, that Pocock was commissioned by Hilhouse to transfer and to recompose onto canvas Hilhouse's own outline conceptions on paper.

In 1782 when the dramatic news of Rodney's victory reached Bristol (where the admiral himself later landed to a hero's welcome), Hilhouse was deeply involved in building large warships for the Royal Navy. Pocock had just exhibited at the Royal Academy for the first time—three watercolours and an oil painting. One of the watercolours was the portrait of the *Arethusa* (pl. 14), commissioned by Hilhouse, and the oil painting depicted an incident in the West Indies hurricane of 1780.

It is very likely that these two Hilhouse paintings precede Pocock's own smaller picture of the Battle of the Saints in the collection of the Society of Merchant Venturers (pl. 40) which the artist was to exhibit at the Royal Academy in 1783. Although the depiction of the *Formidable* is particularly similar, Pocock's later version employs a more distant viewpoint and clarifies the composition, making the sequence of the battle easier to read. These are characteristics which make some of his later battle pieces more lucid and accurate records, but rather duller paintings than his earlier work.

The *Battle of the Saints* is today mostly remembered as the action which first saw a victory by 'breaking the line'—a transgression of contemporary naval doctrine which, by its success at the Saints, was in turn to become a sort of new orthodoxy. But even though the American colonies had effectively been lost in the previous year, the Saints was perhaps one of the two most critical sea battles of the American War of Independence, and of fundamental importance to the future of the Carribean Islands. Since France, Spain and Holland had entered the war, many of the islands had changed hands; Jamaica was threatened, and the trade which was of such special importance to Bristol, was seriously disrupted. The Saints

effectively ended the naval war in the western Atlantic and the Caribbean; moreover, in the peace negotiations of 1783 the strong position which the victory had gained for Britain led to the return of practically all her Caribbean possessions.

In November 1781, Admiral Comte de Grasse arrived at Martinique after his occupation of Chesapeake Bay, which had led to General Cornwallis's capitulation at Yorktown and Britain's virtual defeat in America. Having recovered the island of St. Eustatius he set out to capture St. Kitts and Nevis. St. Kitts was taken but not until after the Battle of Frigate Bay, 25/26 January 1782, in which Admiral Samuel Hood could justly claim to have had the advantage. Pocock's painting of this engagement is arguably his best large battle piece (pl. 42). On 8 April 1782 de Grasse again sailed from Martinique with thirty-six ships-of-the-line and troops for the conquest of Jamaica. Admiral Sir George Rodney's squadron of thirty-six pursued him from St. Lucia and on 9 April the fleets fought a sporadic action along the west coast of Dominica; Pocock's detailed watercolour of the day's fighting is now in the British Museum. Later the French, trying to protect their stragglers and the accompanying transports, sent them into Guadeloupe, leaving themselves with only thirty of the line to confront Rodney.

At dawn on 12 April, de Grasse found himself trapped north of Dominica between the prevailing east wind and the small group of islets called The Saints, where he was obliged to turn and engage his pursuers. As the fleets converged they formed into two long single lines of battle, with the French to windward on a southerly course. This brought their starboard guns to bear and theoretically gave them the tactical advantage, though Rodney himself was noted for his ability for engaging from the leeward side, on which he was now placed heading north. At 7.40

a.m. the *Marlborough*, the first in the British line, opened fire and the two columns of ships began to engage in a fairly conventional line action, However, at about 9.00 a.m. the east wind shifted southerly, heading the French line. The French ships were obliged to bear away in some confusion, turning towards the British. Gaps opened in the French line and ahead of him Rodney, in his flagship the *Formidable,* saw a group of the French ships drifting across his bows. Urged on by his captain of the fleet, Sir Charles Douglas, he turned slightly to starboard and broke through the French line raking the enemy on their unprepared port sides. It is this moment that is shown in Hilhouse's and Pocock's painting. The beleaguered Frenchman on the left of the painting is omitted from Pocock's own version (pl. 40), and is certainly in conflict with the descriptions of the battle which suggest that the French had all turned to starboard.

The line was to be broken in three places, The British fleet subsequently tacked and a general chase began which lasted until 6.30 p.m. when de Grasse in his flagship *Ville de Paris* surrendered to the British second-in-command, Admiral Hood in the *Barfleur.* Rodney then broke off the action, to the great contempt of Hood, who saw the prospect of more prizes. However, caution in risking unnecessary loss in a night action, and other hindsights, justified Rodney's decision. As he told the infuriated Hood the next day, they had 'done very handsomely as it was'.

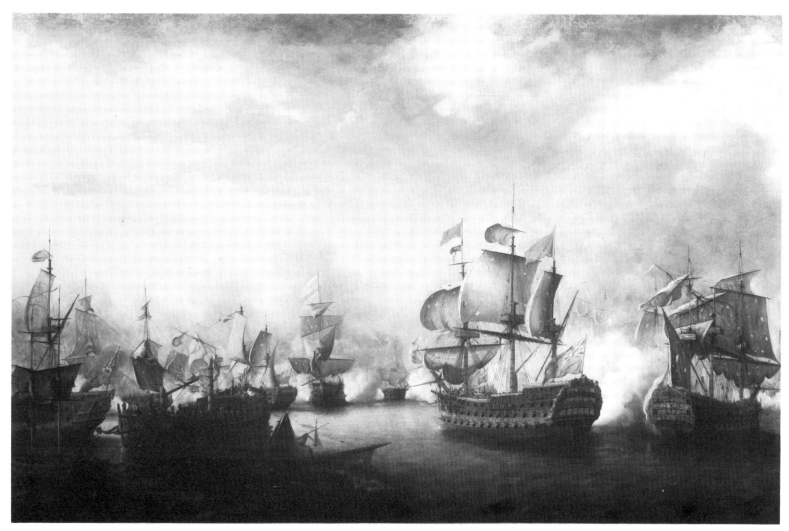

39　The close of the Battle of the Saints　　　*c.*1782

Oil on canvas, 41 x 65 in.
City of Bristol Museum and Art Gallery

Head-on, in the middle distance, is the flag ship of the French fleet, the magnificent *Ville de Paris* of one hundred and ten guns and carrying thirteen hundred men. Her sails are now almost unmanageable and she has turned into the wind unwilling to suffer the indignity of surrendering to the two-decker, *Russell,* that has just raked her stern. A few minutes later the *Barfleur,* seen here advancing towards her, fired a tremendous broadside at almost point-blank range. Admiral Comte de Grasse struck his flag immediately and shortly afterwards Admiral Sir George Rodney ordered his fleet to break off the action.

In the foreground is the dismasted *Glorieux* which had suffered so disastrously in the early morning just before the line was broken but had been towed off by her fleeing countrymen. On the far left is the *Marlborough* which had spearheaded the British line and which, with Hood in the *Barfleur,* had ended the Comte de Grasse's brave defence. On the right a French man-of-war, either the *César,* the *Hector,* or the *Ardent,* strikes her colours to the *Barfleur.*

The action of the afternoon has been concentrated in this painting. The *Glorieux* was taken early in the afternoon as the chase proceeded and although the *Ardent* struck at six o'clock in the evening, it was not to the *Barfleur.* A large drawing by J. M. Hilhouse depicts the *Glorieux, Ville de Paris* and *Barfleur* from exactly the same viewpoint from which they are seen here, although they are placed in different positions. Whether or not Pocock was responding to Hilhouse's direction, he would have been grateful for guidance in the depiction of such large men-of-war, in the drawing of which he was not yet very experienced. The historical inaccuracies are not characteristic of Pocock whose later sea-pieces were often to sacrifice atmosphere to accuracy.

40　The Battle of the Saints; breaking the line　　　1782/3

Oil on canvas, 32¾ x 50 in.
Collection of the Society of Merchant Venturers

This painting was exhibited at the Royal Academy in 1783. It was engraved and published in 1784.

It depicts the moment when the *Formidable,* followed by the *Namur,* has just broken through the French line and now fires on part of the French vanguard, which is in much confusion on the leeward side. On the far right is the *Duke* which, on her captain's own initiative, was also to break the line. Beyond the *Namur* the French line is still on the windward side but the nearest French ship, the *Glorieux,* driven very close to the British line by the changing wind, is about to lose all her masts.

The tactical significance and novelty of breaking the line was very quickly understood and almost all the many pictures of the battle depict this moment.

The *Formidable* is seen from exactly the same viewpoint as in the painting by both Pocock and Hilhouse (pl. 38).

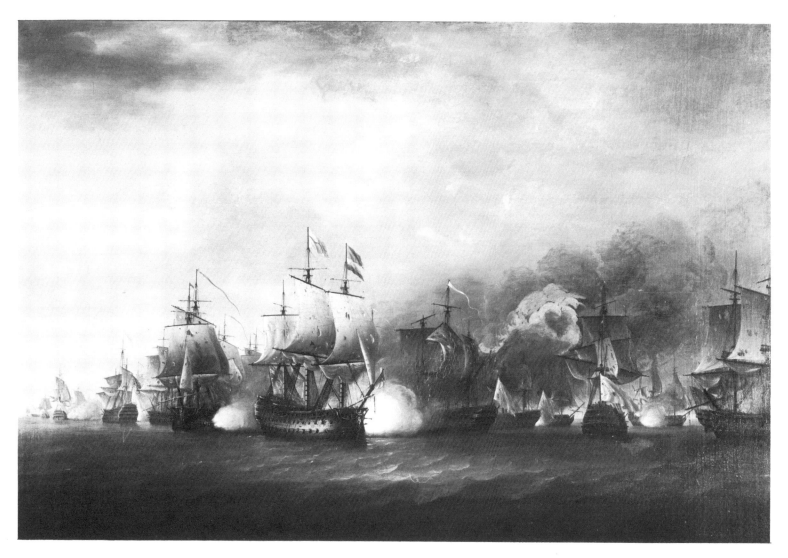

41 The *Caesar*, privateer, beats off a French frigate while protecting a convoy from Jamaica, 27 June 1782 *c.*1782

Etching, aquatint and watercolour, 11⅛ x 16 in.
(platemark)
Engraved by Francis Jukes after N. Pocock
City of Bristol Museum and Art Gallery

On 27 June 1782 Captain Valentine Baker in the privateer *Caesar,* then of twenty guns and seventy men, fought off a determined attack by a French frigate of thirty-two guns. The frigate struck her flag but the *Caesar* was too damaged to take possession and the Frenchman slipped away. The grateful merchants and insurers of Bristol presented Captain Baker with a handsome silver vase.

The *Caesar* had first traded with Jamaica before being converted to a copper-bottomed privateer in Sydenham Teast's dock at Wapping in 1779. She was exceptionally successful and, amongst many prizes, was a Dutch ship bound from Curacao to Amsterdam, taken in 1781, whose cargo was sold for £36,000.

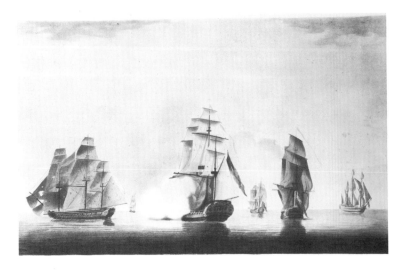

42 The Battle of Frigate Bay, 26 January 1782 1788

Oil on canvas, 48 x 84 in.
Signed and dated: *N Pocock 1788*
The National Maritime Museum, London

Although painted five years after the completion of the painting of the Battle of the Saints and exhibited at the Royal Academy in 1788, this work depicts an important engagement that occurred three months before the more decisive battle.

Soon after his return from Chesapeake Bay, Admiral de Grasse retook St. Eustatius and several small British islands and, before setting forth to take Jamaica, determined to capture St. Kitts. Rear Admiral Sir Samuel Hood, as soon as he heard of the invasion, determined to attack de Grasse at anchor off Basseterre, St. Kitts. But the French were alerted and put to sea. In a bold manoeuvre Hood occupied the French anchorage on 25 January, moving his ships into a tight dog-leg formation and forcing his attacker to face the full fire of either one or the other half of the British line. Twice on 26 January the French vainly tried to break through and, as can be seen here, suffered considerable damage. Nevis Peak rises in the distance.

cont. p. 64

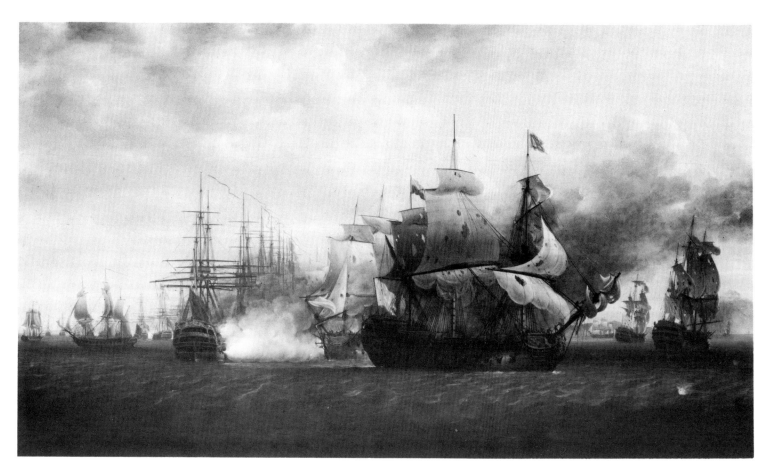

Hood's ships slipped away at night and the island did fall to the French in February but the battle had delayed French preparations for Jamaica. Admiral Sir George Rodney with vital reinforcements was at this time still on passage from England.

43 Bristol harbour with the Cathedral and the Quay 1785

Oil on canvas, 22½ x 32 in.
Signed and dated: *N Pocock 1785*
City of Bristol Museum and Art Gallery

There are considerable differences between this view and the earlier engraved version that first appeared in 1782 (pl. 22). But the differences between this oil painting and the large watercolour at Lotherton Hall, Leeds, also dated

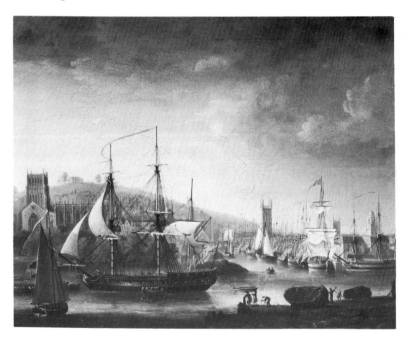

1785, are limited to the foreground figures and to the details of the thirty-two-gun frigate being towed downstream and of the two nearest vessels at the quay near the end of Prince Street. The figureheads, for example, are distinct and different. It is possible that these vessels are specific portraits and that the painting was commissioned by Thomas Daniel, a West Indies merchant and shipowner. Daniel was admitted a Freeman in 1785 and elected a common councillor in the same year. He was later to be Mayor and so powerful in corporation affairs that he was known as 'the King of Bristol'. The painting, dated 1785, was owned by his descendants at the end of the nineteenth century.

44 The Avon Gorge at Sunset *c.*1785

Oil on canvas, 36 x 52 in.
Collection of the Society of Merchant Venturers

A ship of at least thirty-four guns is being towed downstream by forty oarsmen in five boats.

Apparently nestled in the woods of Abbots Leigh on the Somerset side of the river is a rare glimpse of the imposing castellated manor of Abbots Leigh, home of the Gordon family, West Indies merchants. It was to be demolished early in the nineteenth century and replaced by Leigh Court on a higher and more distant spot. Cook's Folly and Sea Walls are on the right. A smaller variant of this painting, in a private collection, is dated 1785.

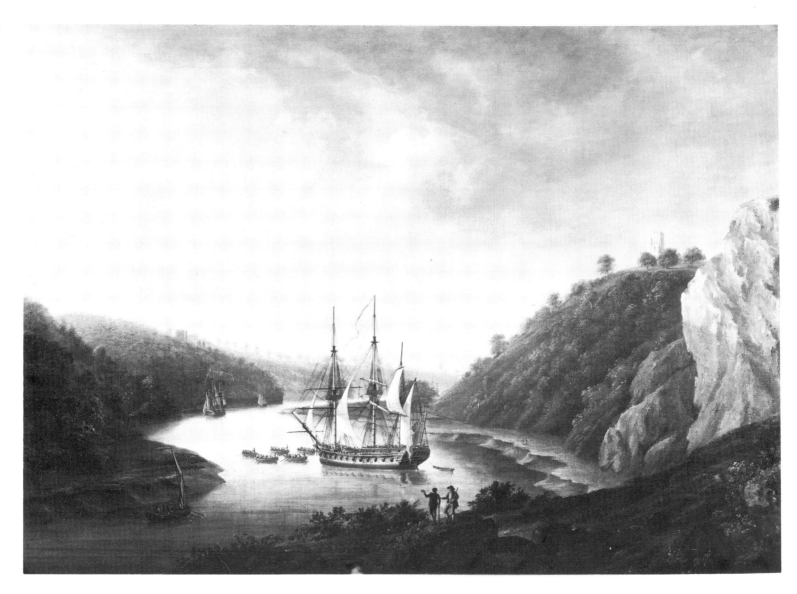

45 A View from St. Kitts towards the Island of Nevis with Nevis Peak and Charleston 1787

Oil on canvas, 15⅜ x 23½ in.
Signed and dated: *N P Bristol 1787*
Private collection

The composition and in particular the rocks, the waves and the treatment of the figures are very close to Claude Joseph Vernet's painting, *The Storm*, of which Boydell had published an engraving in 1782. Pocock was to use Vernet's composition again in the same year, 1787, for the watercolour view of *Kingroad from Portishead Point* (pl. 37) and on that occasion the ship is being driven towards the rocks with its sails flapping and sheets loose as in Vernet's painting.

In taking advantage of a composition by Vernet, Pocock was paying specific attention to a letter from Sir Joshua Reynolds of 4 May 1780. Reynolds had advised him to imitate Vernet's ability for 'uniting landscape to ship-painting'.

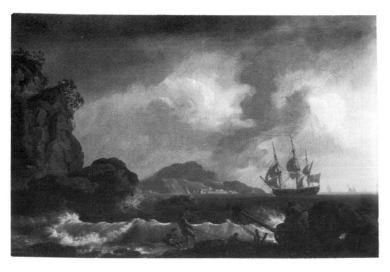

Pocock almost certainly visited or passed by Nevis on each of his six voyages to the West Indies between 1771 and 1776. His last voyage in the snow *Minerva* was to Nevis itself, but the logbook for this voyage is now untraced.

46 A View of Nevis from St. Kitt's 1790

Oil on canvas, 60 x 96 in.
Signed and dated: *N Pocock 1790*
Private collection

This vast painting is one of the most dramatic visual reminders of Bristol's dominant role in the West India trade. The citizens of Bristol owned a significant proportion of the land in the islands and controlled a very large portion of the trade. It was the Society of Merchant Venturers that was the chief lobbyist at court and at Westminster on the islands' behalf. The celebrations in Bristol that greeted the news of the Battle of the Saints in 1782 (pl. 38 – 40) reflect the citizens' consciousness of the source of much of Bristol's prosperity. That victory enabled the serenity of this scene, so crowded with British merchantmen of varying sorts and sizes, to continue.

The painting remains with the descendants of John Pinney whose Bristol town house in Great George Street is now the Georgian House, a part of the Museum and Art Gallery. That house was completed in 1790 and it is likely that Pinney himself commissioned the painting which was finished in the same year, from Pocock.

John Pinney had inherited the Pinney estates in 1762 and from 1764 to 1773 he had managed the lands on Nevis. Like Horatio Nelson he married the daughter of an Englishman living on the island. He was to return to Nevis several times and one such visit was made in 1790.

Pocock's first exhibit at the Royal Academy in 1782 was of a scene in the West Indies, and besides the various views of the Battle of the Saints, Pocock exhibited several scenes of the island of Dominica in the later 1780s. Apart from the previous painting of 1787 (pl. 45) another *View of Nevis* by Pocock is in a Bristol collection.

Although dated 1790, the year after Pocock's move to London, it is likely that this painting was commissioned by John Pinney before the artist's departure.

46

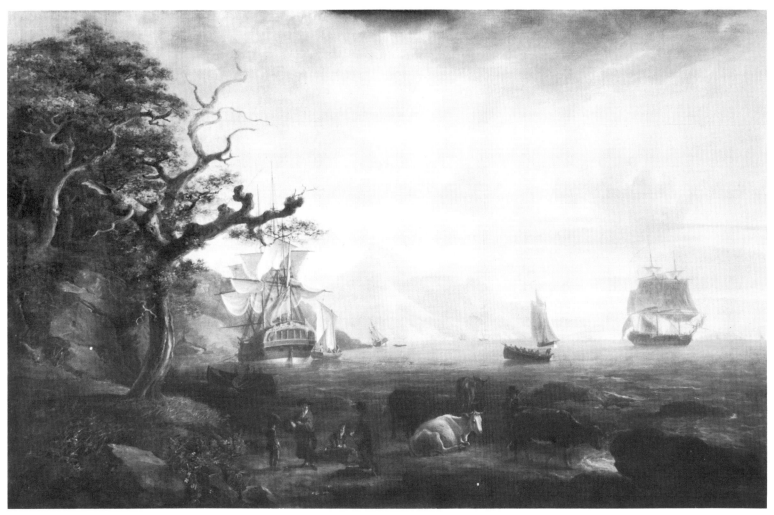

JOSEPH WALTER

'It might be expected that marine painters should abound in a great commercial seaport like Bristol; but with the exception of the late Mr Pocock, long ago removed from Bristol, and Mr Rowbotham, who was among the early associates of E. Bird, we do not recollect that any artists of the least merit in that line have preceded the present exhibitors. This pleasing picture and some others, which will be noticed in their order, prove the very great progress Mr Walter has made within a few years.'

Dr John King was here reviewing the Bristol Society of Artists' exhibition of 1839 in the *Bristol Mirror*. It was one of the very few public notices Joseph Walter was to receive until brief obituaries recorded his death in 1856. He was then, we learn, in his seventy-fourth year.

Walter was born in the parish of St. Thomas, Bristol in 1783 but from early boyhood was said to have been connected with the parish of St. Augustine which then encompassed the Cathedral and adjoined the quayside. In 1829 he was listed amongst the many artists receiving free tickets to an exhibition at the Bristol Institution in Park Street and in 1832 he exhibited there, giving his address as Portishead where he must have lived for a time. For the last twenty years of his life, from 1836, the Directories record Walter as living as a 'Marine Painter' at various addresses in Trinity Street which ran from the east end of the Cathedral to the harbour. He died at No. 28, a modest terrace house in which two other families lived. Walter's latest work is dated 1851 (pl. 60) and his obituary states that he had suffered a long and painful illness of four years and two months.

There is, as yet, no precise evidence concerning Walter's earlier career. Nor do we know when he became a professional artist. His complete familiarity with ships of every kind prompts the suggestion that he too, like Pocock, went to sea. The census returns of 1851 do record that his eldest son, Theodore, aged twenty-four, was a mariner. However, his second son, George, aged twenty-one, was a clerk to a share broker and Arthur, aged fifteen, was still at school. In the poll books for several elections until 1837 there is a Joseph Walter, accountant at St. Augustine's Back. This Joseph Walter was a freeman and son of William Walter, horner of the parish of St. Thomas in which we know that the future artist was born. In the subsequent poll book for 1841, Joseph Walter, 'Marine Painter', appears at the Trinity Street address which the Directories had first recorded in 1836. In the 1847 poll book he is listed under 'Freemen'. However, it is not at all certain that the accountant and the marine painter are the same person.

Of Walter's training as an artist we are also ignorant and not enough of his earlier works are dated to be able to form any sure idea of his stylistic development. But his earliest paintings, so far known, are undoubtably the two opposing views across the bay at Portishead just below the mouth of the Avon (pl. 47, 48)

Neither picture makes any obvious reference to any other artist. In each the foreground is very plain and the subject matter is confined to a band evenly spaced across the picture. The conventions of landscape composition are ignored. Instead they are paintings of extraordinarily concentrated observation. In the view from Portishead an autumn storm, preceded by a rainbow, pursues a steam packet, a merchantman and many coastal craft as they hasten to the mouth of the Avon. The effects of light, atmosphere and space are convincingly portrayed and the

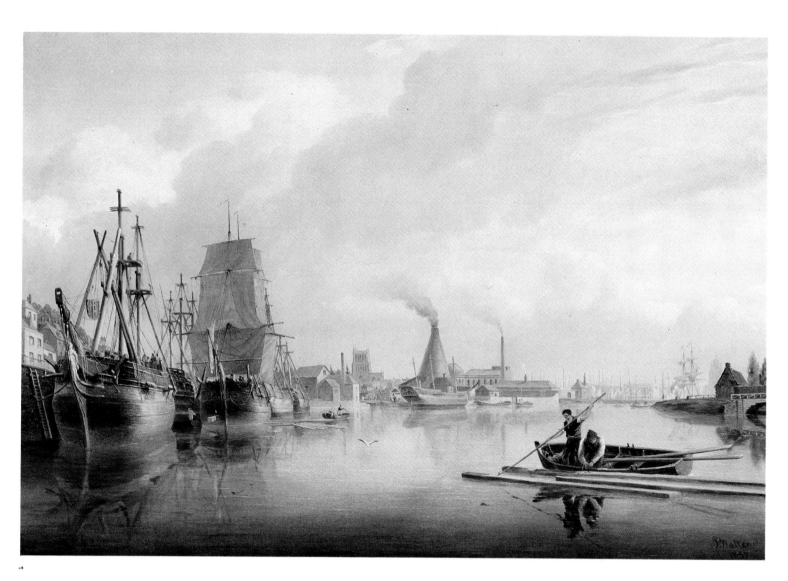

The Floating Harbour, Bristol, 1837 *see page 87*

incidential details, such as the muck spreading or house building, heighten the realism and sense of actuality. In the painting looking from the channel towards Portishead, Walter bravely puts his foreground and most of the ships into the shade and looks into the light. The colours and tones of the sky alter slowly and with great subtlety.

It is possible that the technique and the diligence of Walter's observation of nature and his control of aerial perspective were in part inspired by Francis Danby whose work continued to be shown in Bristol after his departure for London in 1824. But by 1830 the impetus and originality of the Bristol School of artists had began to decline. Even as Walter's work was developing during the 1830s he was to prove himself remarkably free of the influences of Bristol's leading artists of that decade, J. B. Pyne and W. J. Muller.

Although Walter maintained his independence, the simplicity of these two works was to be replaced by more sophisticated artifice. The compositional devices used to enliven and give depth to the foregrounds of the three views of Bristol harbour (pl. 55 – 57) are typical. But each of these three scenes, painted from a low viewpoint at the water's edge, remain intimate portraits of the life of Bristol's harbour and its shipping. The towers of the Cathedral and of St. Mary Redcliffe receive less notice than the gasworks or the Bush warehouse. The earliest of these paintings is dominated by a mellow evening light (pl. 55). The view with Childs Glass House so firmly in its centre has the harder, brighter colouring of midday (pl. 56). In the third painting of 1842 the early morning sun is hidden behind clouds above St. Mary Recliffe, the quayside is crowded and there is much activity aboard the ships.

In the three views on the Avon depicting Pill, Hungroad and Sea Mills there is the same emphasis on the life of the river and its ships, even when the landscape dominates the scene (pl. 52 – 54). Except for the two early Portishead views, Walter showed little interest in painting landscape. His judgement concerning colour was sometimes at fault although this may have been a failing of old age. His obituary suggests that 'advanced age and bodily affliction had impaired his powers'.

The apparent quality of some of Walter's paintings has been affected by one aspect of his technique. He undoubtedly used glazes extensively, especially over the water in the foreground of his paintings in order to obtain both density and translucency. These glazes have proved to be very susceptible to inexpert restoration which has left many paintings looking extremely thin in the foreground and has often prompted extensive overpainting. Many works, however, do remain in remarkably good condition.

Dutch vessels in a breeze (pl. 58) is one such painting. It also shows an easy assimilation of the best of English marine painting in the tradition of the Van de Veldes, and it has a convincingly fresh atmosphere and sense of movement in the light as well as in the vessels and the sea. Walter painted many such views of Dutch shipping. He painted also a great variety of vessels before harbours or islands such as Southampton, Malta or St. Lucia.

The importance of dealers to such specialist artists as Walter at this period has yet to be clearly established, but it is very possible that one outlet was the bookseller, stationer and picture dealer, John Norton of Corn Street in Bristol. Between 1813 and the early 1830s Norton had purchased two hundred and twenty-seven of Thomas Luny's seascapes and coastal scenes. Luny was working very successfully at Teignmouth throughout this period after many years in London. Walter may well have

succeeded Luny as the leading marine artist in the West Country, and there could be a link between Luny's incapacity to paint in the year or so before his death in 1837 and the emergence of Walter as a marine painter. It was in 1836 that Walter was first listed in the Directories as a 'marine artist' living in Trinity Street. From this year also comes his earliest dated painting (pl. 55) and the first of his three successful submissions to the Royal Academy.

The assistance of a dealer could explain the paucity of Walter's pictures at London exhibitions. At the Royal Academy and at the Society of British Artists in Suffolk Street, he showed only ten works between 1834 and 1849. Some of these may well have been watercolours for in 1842, when he showed ten works at the exhibition of the Bristol Society of Artists, three of the exhibits were watercolours.

The style of these works, of which only three are known today in the collection of the City of Bristol Museum and Art Gallery, is the closest link between Walter and his fellow artists in Bristol. Two of them are sepia drawings and come from an album of monochrome wash drawings by other artists working in Bristol in the 1830s. Earlier in the decade there had been a revival of the evening sketching meetings which had been such an important aspect of the Bristol School of the 1820s. Samuel Jackson was the artist linking the two groups and it is his technique that Walter most closely follows. Walter's three drawings are extremely competent but they lack individuality.

One obituary notice stated rather patronisingly that Walter had received a 'wider celebrity' as a result of the engravings of his paintings and drawings of the *Great Western* and the *Great Britain*. Walter proved himself to be a worthy chief portraitist of these two great steamships and the large number of engravings that he produced is as much a measure of the interest that surrounded these ships in their first months, as of Walter's success in expressing and evoking that enthusiasm. Except for one straightforward portrait of the *Great Western* (City of Bristol Museum and Art Gallery), all these pictures are ambitious and very varied in their treatment. His paintings and engravings of the *Great Western* in Kingroad, surrounded by steam packets and small boats (pl. 62), and of the launching of the *Great Britain* amidst vast cheering crowds (pl. 65), do successfully convey the public's excitement. But it is the less dramatic scenes that are the more moving. The lithograph of the *Great Western* near Pill, her sails limp, taking on coal, has the accuracy and interest in the incidental so characteristic of much of Walter's work (pl. 64). The painting of the *Great Britain saluting a man-of-war in Kingroad* (pl. 68) may not have the grand pathos of Turner's *Fighting Téméraire*, which was exhibited in the Royal Academy in 1839, but it has all the truth a mariner might demand.

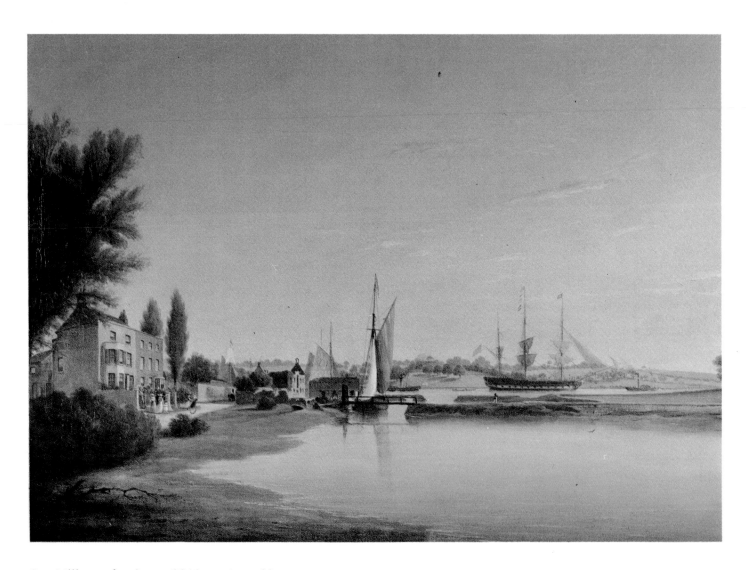

Sea Mills on the Avon, 1844 *see page 83*

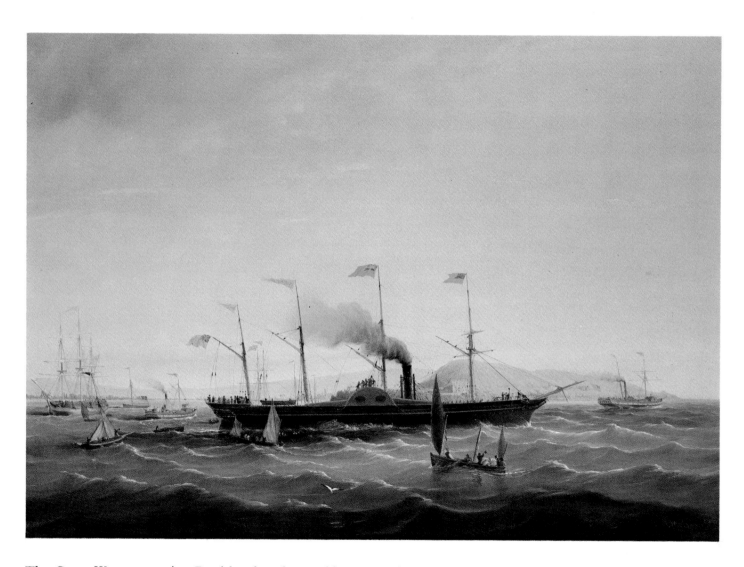

The *Great Western* passing Portishead on her maiden voyage, 1838 *see page 94*

Illustrations

JOSEPH WALTER

47 **A view from Portishead towards Wales** *c.* 1832

Oil on canvas, 19 x 25 in.
City of Bristol Museum and Art Gallery

Many vessels are hastening into Kingroad before an approaching storm. Denny Island can be seen beyond the steam packet.

In 1832 Walter exhibited three paintings at the Bristol Society of Artists and gave his address as Portishead. The style and quality of this remarkable early work and of its probable companion (pl. 48) are discussed on pages 68 and 70.

48 **A ship passing Portishead** *c.* 1832

Oil on canvas, 19¾ x 25⅞ in.
Signed: *J. Walter*
City of Bristol Museum and Art Gallery

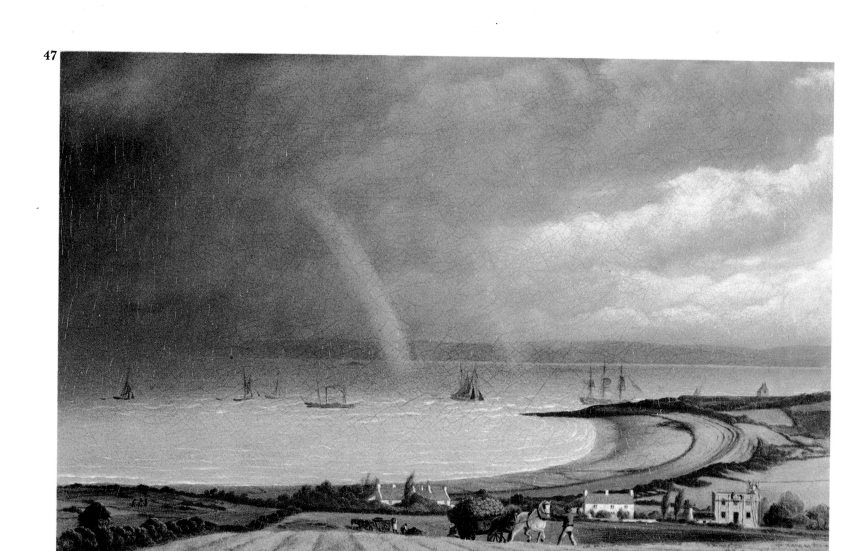

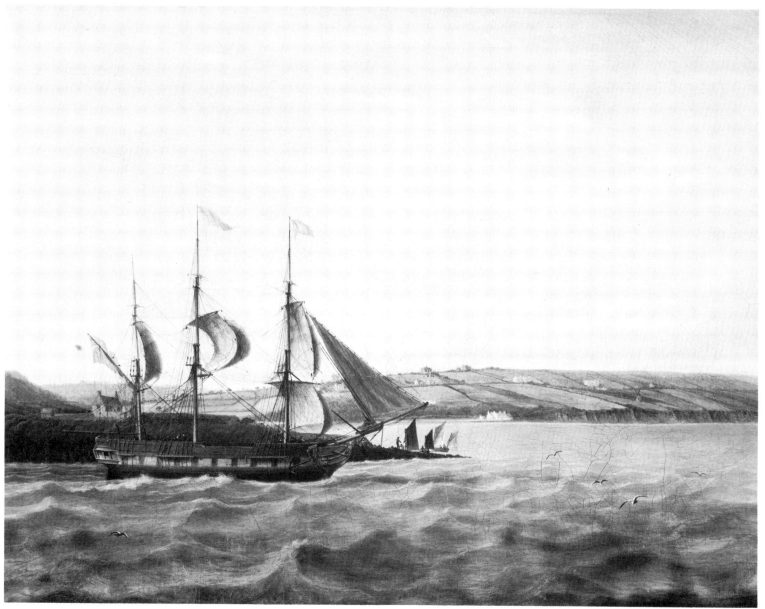

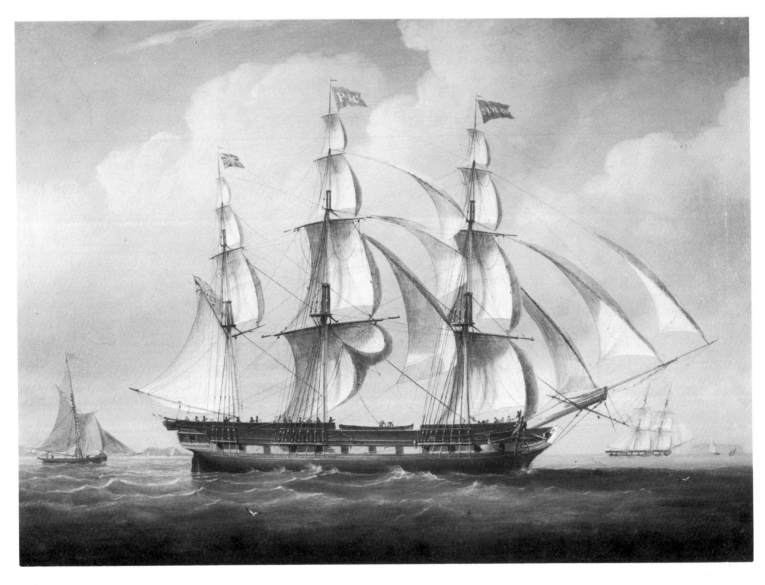

49 The ship *Severn* *c.*1835

Oil on canvas, 21 x 30¾ in.
Signed: *J. Walter*
City of Bristol Museum and Art Gallery

Walter's portrait almost certainly depicts the *Severn* of four hundred and seventy-eight tons built by James Martin Hilhouse for Protheroe and Claxton in 1805 for the West India trade. Captain T. E. Etheridge was her first commander and this painting was presented to Bristol Art Gallery by his great grandson. It might be expected that the painting had been commissioned by the Captain in the 1830s as a remembrance of his earlier command. However the *Severn* is carrying a large number of passengers in distinctly contemporary dress.

50 The mouth of the Avon; dropping the pilot 1837

Oil on canvas, 34 x 49 in.
Signed and dated: *J. Walter 1837*
City of Bristol Museum and Art Gallery

The merchantman has just sailed up the Bristol Channel and heaves to, having dropped the pilot and some passengers. She will probably now drop anchor either to await the tide to go up the Avon to Bristol, or to pick up or discharge passengers and cargo at this spot without entering the river. The ship anchored beyond her to the left has signalled her departure and for a pilot.

The smaller craft to the right of the centre are Severn trows, sloop or ketch-rigged coastal sailing barges that carried goods far up the River Severn and down the Bristol Channel as far as Cornwall.

There is a version of this painting of a similar size in the collection of the National Maritime Museum, London. There are many differences, notably a dramatic line of vessels in the distance sailing out of the mouth of the Avon. In another very much smaller and later painting of the same view in the City of Bristol Museum and Art Gallery, the vessels are about to sail up-river with the tide.

51 The new lighthouse at the mouth of the Avon 1840

Oil on canvas, 25½ x 35½ in.
Signed and dated: *J. Walter 1840*
Private collection

The Avon lighthouse, built for the Corporation of Trinity House, was completed in 1840 and first lit in June of that year. Walter makes the tower taller than it was and he presumably based his painting upon the architect's plans. He did in fact exhibit a painting of the same title at the Bristol Society of Artists' exhibition in 1839, before the lighthouse was completed, and the two paintings could well be one and the same, despite the inscribed date.

Just visible are the two identical keepers' houses on either side of the tower. Each house had six rooms and the whole was surrounded by a moat. It was demolished in 1902 for the building of the Royal Edward Dock.

The Severn trow in the foreground demonstrates how little freeboard these coastal vessels had when fully loaded.

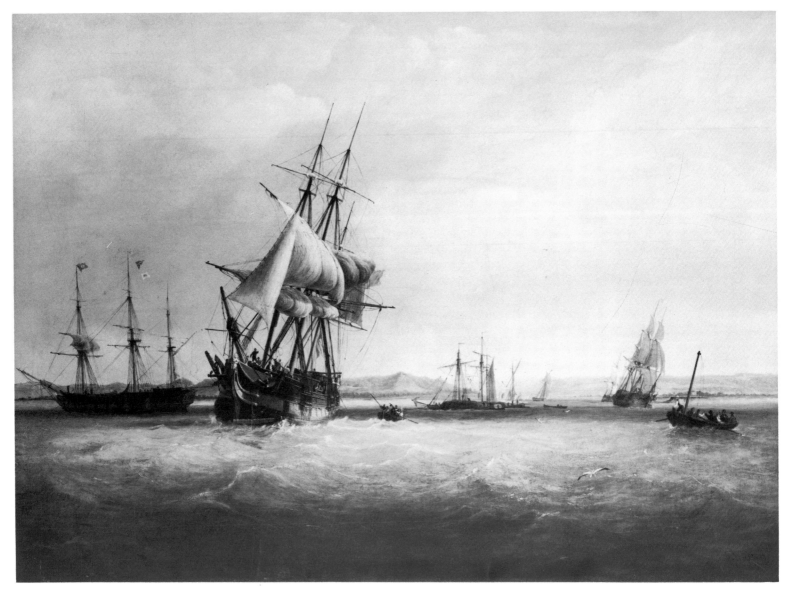

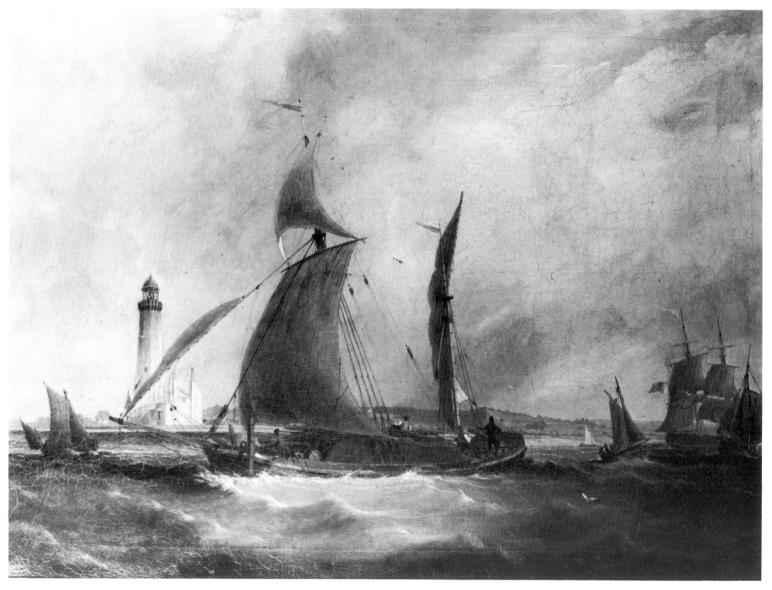

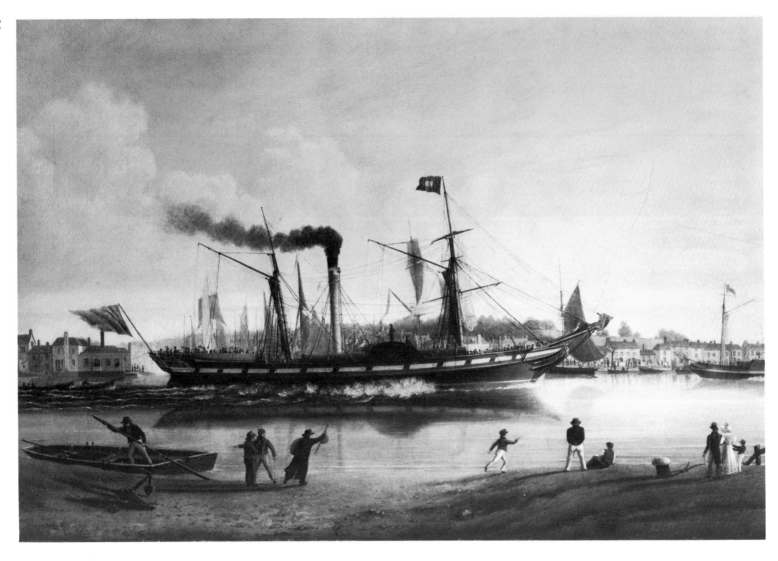

52 A steamer on the River Avon passing Pill *c.*1835

Oil on canvas, 19¾ x 29½ in.
Collection of J. C. G. Hill Esq.

The first steamer to operate a regular passenger service in the West Country was the *Charlotte* which in 1813 and 1814 ran on the River Avon between Bristol and Bath. Not until 1821 did a regular service operate from Bristol into the Channel and beyond. By the following year steam-packet services were scheduled between Bristol, Cork, Dublin, Swansea, Newport, and Chepstow. Many further services quickly developed. By the 1860s the expanding railway network was causing a rapid decline in the steam-packet fleets.

53 Hungroad above Pill with the mouth of the Avon beyond
1838

Oil on canvas, 21½ x 37½ in.
Signed and dated: *J. Walter 1838*
Private collection, Bristol

For centuries Hungroad had been an important sheltered anchorage just above Pill, which is here hidden behind a merchant ship.

It was at Pill that many of the pilots and towing men lived. These men had suffered earlier in the nineteenth century by the construction of a towpath from the Floating Harbour to Pill enabling horses to tow smaller vessels up and down the river. In 1836 the steam tug *Fury* first appeared and caused riots at Pill. Only two years later we see in this painting two tugs in the distance bringing up a ship.

54 Sea Mills on the River Avon 1844

Oil on canvas, 26 x 36 in.
Signed and dated: *J. Walter 1844*
City of Bristol Museum and Art Gallery

Sea Mills is half-way between Bristol and the mouth of the Avon. The remains of the substantial eighteenth-century dock and its warehouses, abandoned seventy years earlier, are still to be seen in this painting (see pl. 36).

On the river a steam packet hastens upstream and a steam tug tows a merchantman to Kingroad. The flags on her main mast read 1.4.2., but not exactly according to the subsequent *Universal Code of Signals,* and signify only that she is proceeding to Kingroad.

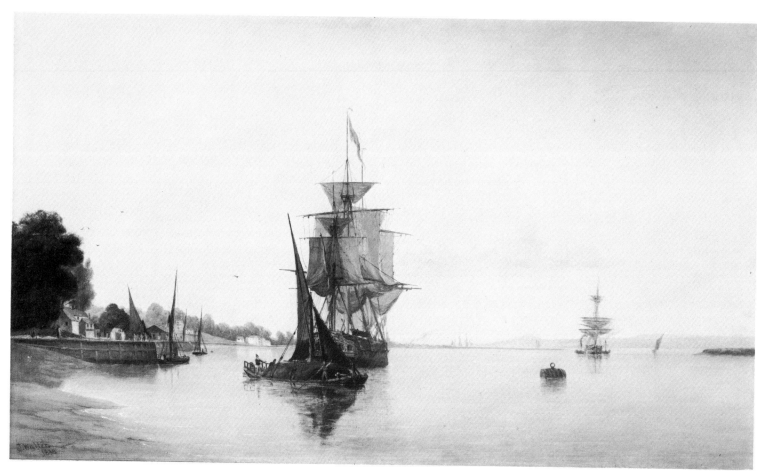

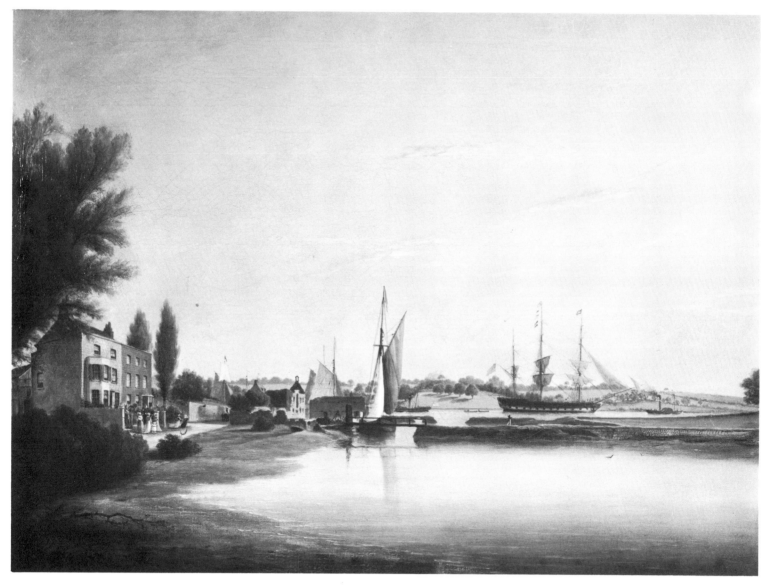

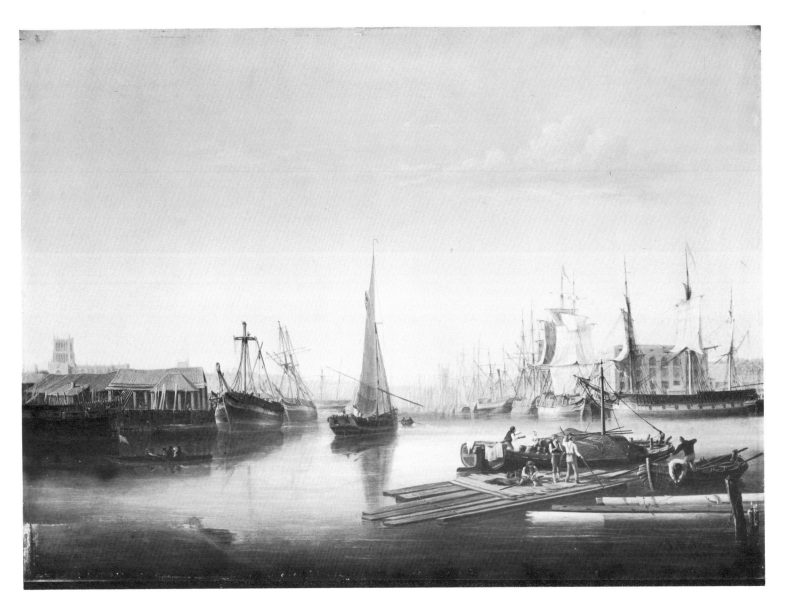

55 Bristol Harbour **1836**

Oil on canvas, 26 x 36 in.
Signed and dated: *J. Walter 1836*
City of Bristol Museum and Art Gallery

In the foreground of this quiet evening scene old spars are
tied to a mooring post. A raft of new timbers is next to a
Severn trow which has presumably come up the river to
the Cumberland Basin under horsepower and would now
be towed by a rowing boat to the quayside. One paddle
steamer is at Broad Quay amongst numerous sailing
vessels. On the opposite side a timber ship, distinguishable
by the hatch near the waterline in the bow, is having her
masts stepped. The docks beyond had been developed in
the 1790s but were filled in ninety years later.

On the left is the Cathedral and the tower of St.
Augustine's. On the right is St. Stephen's, and at the end
of the Quay, the recently-erected tea warehouse before
which two merchantmen are drying their sails.

56 The Floating Harbour, Bristol **1837**

Oil on canvas, 23 x 33½ in.
Signed and dated: *J. Walter 1837*
City of Bristol Museum and Art Gallery

On the left a large piece of timber is actually projecting
from the hull of the timber-ship whose sails are drying in
the sun. Much of the timber would be floated to its
destination and even stored in the water. It is very likely
that some of it was destined for Hilhouse's dockyard
opposite. The entrance to the most upstream of the three
docks, built in 1820, can just be seen on the extreme
right.

The merchant-ship on the left with a fine figurehead is
having her masts stepped. Below the Cathedral the masts
and stern of a vessel can be seen in Limekiln Dock. Childs
Glass House, now producing bottles for J. Nicholas & Co.,
is soon to be demolished. Beyond it are the buildings of
the Bristol and Clifton Oil Gas Company. From 1823 gas
had been produced here from oil but fluctuating oil prices
had prompted a change to the more conventional coal
process by 1830. Some of these very fine buildings survive,
roofless, today.

In the distance, beyond Sea Banks and Canon's Marsh,
are the masts of vessels at Broad Quay. The tea
warehouse has just doubled its original size (pl. 55) and
assumed its vital and dominant position, so crucially and
impressively maintained when it was restored and
converted in the 1970s.

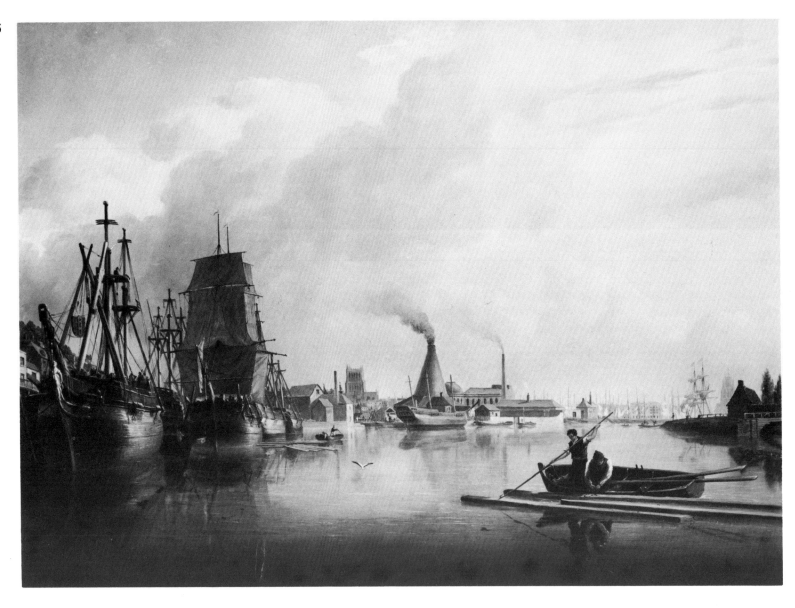

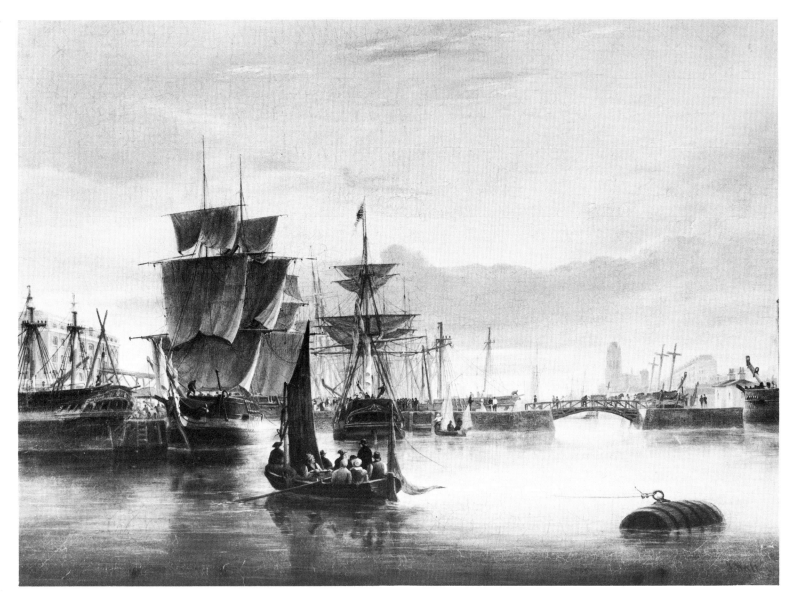

57 The Floating Harbour, Bristol with Prince Street Bridge
1842

Oil on canvas, 26 x 36⅛ in.
Signed and dated: *J. Walter 1842*
City of Bristol Museum and Art Gallery

This early morning scene of much activity shows very clearly Prince Street Bridge built in 1809 as part of the creation of the Floating Harbour from 1804 to 1809. This great scheme had diverted the tidal waters of the Avon into a 'New Cut' from Totterdown to Rownham and turned the old river into one vast dock from the newly-constructed Cumberland Basin to Bristol Bridge. No longer did every vessel have to submit to the risks of straddling the mud and rock of the river bed, twice a day.

Prince Street Bridge continued as a toll bridge until 1876 when the Corporation bought it and promptly ended an old public grievance by abolishing the tolls. The toll houses can be seen on the right of the bridge in this painting. In 1879 the present bridge was opened. It was operated as it is today, by hydraulic power, now provided from as far away as Underfall Yard near Cumberland Basin.

The wherry in the foreground may be the ferry that operated between Canons' Marsh and Broad Quay.

58 Dutch vessels in a fresh breeze

Oil on canvas, 12½ x 17⅜ in.
Signed and dated: *J. Walter 1851* (?)
Private collection

Walter did several paintings of Dutch vessels and this is an outstanding example in which he paints with much confidence in the tradition of the Van de Veldes.

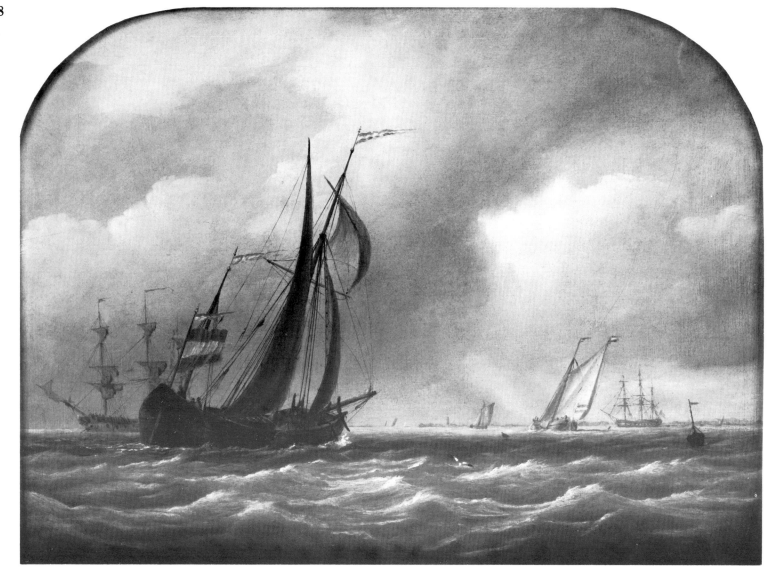

59

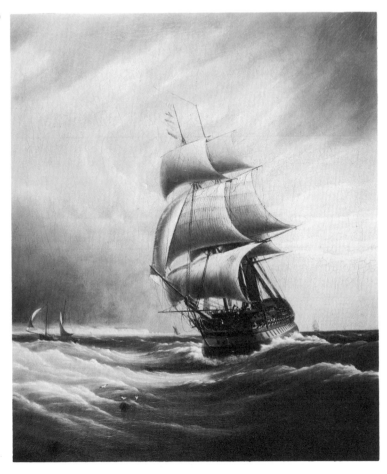

59 Three masted ship before the wind

Oil on canvas, 33¼ x 24 in.
City of Bristol Museum and Art Gallery

The ship is a two decker of about ninety guns. The signal hoist on the foremast denotes her position off the Needles, which can be seen in the background. She may be an armed merchantman rather than a normal ship-of-war and, if so, would be an East Indiaman. Such a ship was usually larger, grander and more heavily armed than the ships sailing from Bristol to the West Indies in the eighteenth and early nineteenth centuries.

60 The brig *Arab* 1851

Oil on canvas, 22 x 30 in.
Signed and dated: *J. Walter 1851*
Private collection

The flag signals correspond exactly with the *Universal Code of Signals* but only confirm the vessel's name.

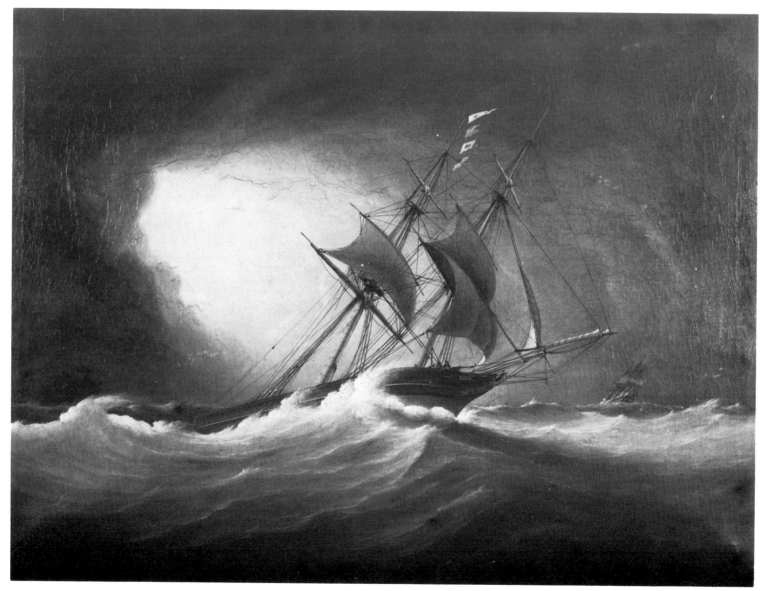

61 The *Great Western* leaving Cumberland Basin 1837

Lithograph, 7⅘ x 12 in. (image)
Inscribed in the plate: *J. Walter del et litho./Printed by C. Hullmandel/THE GREAT WESTERN STEAM SHIP,/intended to trade between BRISTOL and NEW YORK./leaving Cumberland Basin on the morning of the 18th Aug: 1837, in tow of the Lion Steam-Tug and accompanied by the Benledi and Herald Steamers,/for the purpose of proceeding to London to receive her Engines.*
City of Bristol Museum and Art Gallery

The *Great Western* was first conceived by I. K. Brunel as an extension to New York of the Great Western Railway from London to Bristol, a line which was not completed until 1841. The Royal Western Hotel, now Brunel House, was built in 1837 for the overnight accommodation of the passengers between the railway terminus and the steamship.

The *Great Western* was launched on 19 July 1837 from William Patterson's dock at Wapping. She was the largest steamer afloat and the first to be built expressly for crossing the Atlantic.

On 18 August she left Bristol for London to have her engines fitted, accompanied by a tug and two steam-packet boats, one of which had been making regular runs to Cornwall while the other had been running a service along the Welsh coast.

62 The *Great Western* passing Portishead on her maiden voyage to New York, 8 April 1838

Oil on canvas, 20 x 28 in.
Signed: *J. Walter*
Private collection

After trials following the fitting of Maudsley's vast engines in London, the *Great Western* left for Bristol in order to pick up her passengers for her first crossing to New York. A race had developed with the much smaller steamer, *Sirius,* for the prize of opening the first regular transatlantic service.

The *Great Western* caught fire in the Thames estuary, an incident in which Brunel himself was nearly killed. By the time the steamship reached Kingroad on 2 April, most of her passengers had cancelled their reservations having heard that the *Great Western* had been destroyed. Thus only seven passengers were aboard when she left a week later for New York. Walter's crowded decks are a little misleading.

The *Sirius,* having left Cork four days before the *Great Western* left Bristol, arrived in New York only a few hours

earlier after being at sea for nineteen days. Both vessels received a triumphant reception. A lithograph after this painting was made by Edward Duncan. It was printed by Day & Haghe and published by George Davey of Bristol.

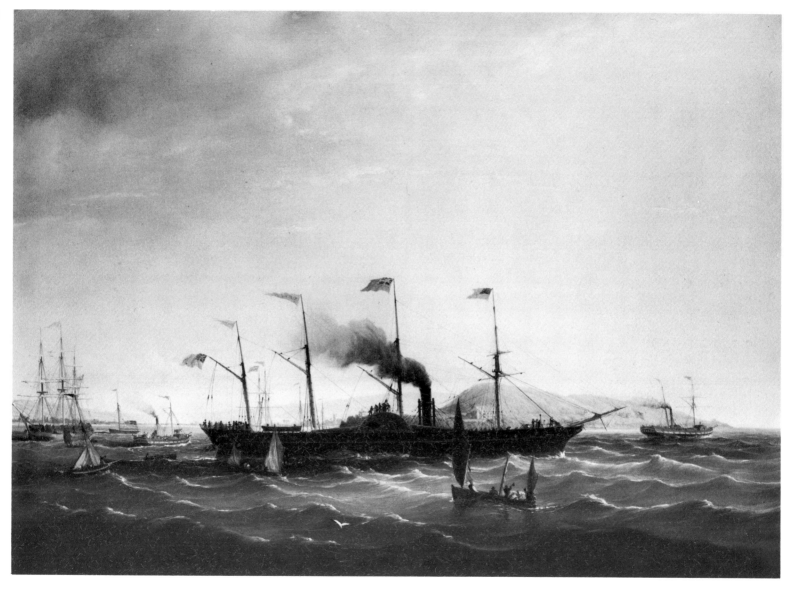

63 The *Great Western* on her fifth passage from Bristol to New York in November 1838 1839

Oil on canvas, 35¼ x 55½ in.
City of Bristol Museum and Art Gallery

This painting bears the following inscription on its magnificently decorated frame:

> 'The Great Western on her fifth passage from BRISTOL to NEW YORK. She left BRISTOL on 27th Oct. 1838, weathered the great gale of the 28th and 29th and in Lat. 49. Lon. 26. on the evening of November 2nd encountered a more violent gale which lasted without a lull 48 hours from W.N.W. Her average rate of steaming in the gale was 3 knots. — She passed the SIDDONS Liner lying to on the 3rd. and after a succession of foul winds and bad weather arrived in NEW YORK on the 15th November.'

Brunel had, of course, been conscious of the great longitudinal stresses upon such large a ship and he had

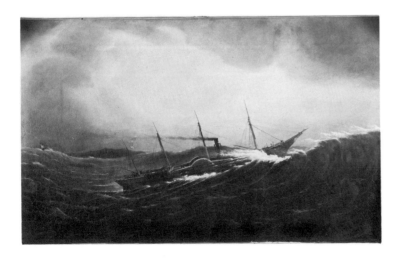

taken special care to give unprecedented strength to the two hundred and thirty-six foot wooden hull.

64 "THE GREAT WESTERN. Lying at her Moorings at Broad Pill."

Lithograph, 9¾ x 10 ³/₁₀ in. (image)
Inscribed in the plate: *I. Walter. Pinxd./Scale of 40 feet to an Inch/Lithograph'd & Published by T. Bedford at 4 Broad Quay Bristol.* and as the title
City of Bristol Museum and Art Gallery

The *Great Western* is shown a short distance up the river Avon, below Pill, drying her sails and taking on coal and passengers. She has presumably only just arrived. She was to prove an extraordinarily reliable ship completing sixty-seven transatlantic crossings in eight years.

The *Great Western* did not return to Bristol itself but took on passengers here or in Kingroad. A fine aquatint after Walter was published in 1840 by Thomas Freebody and others, which depicts the *Great Western* in Kingroad surrounded by numerous vessels and taking on passengers from a small paddle-steamer. Despite the fact that she did not enter Bristol docks, the Bristol Dock Company levied dues of £106 per trip and still more on the cargo.

The *Great Western* had a dramatic effect on the reputation of Bristol as a major seaport, but it was perhaps only a delaying action. For too many years nothing came of the serious consideration then being given to the construction of docks and piers near the mouth of the Avon, and the *Great Western* was to turn to Liverpool in 1842, the port at which the *Great Britain* was to be based throughout her career as a steamship.

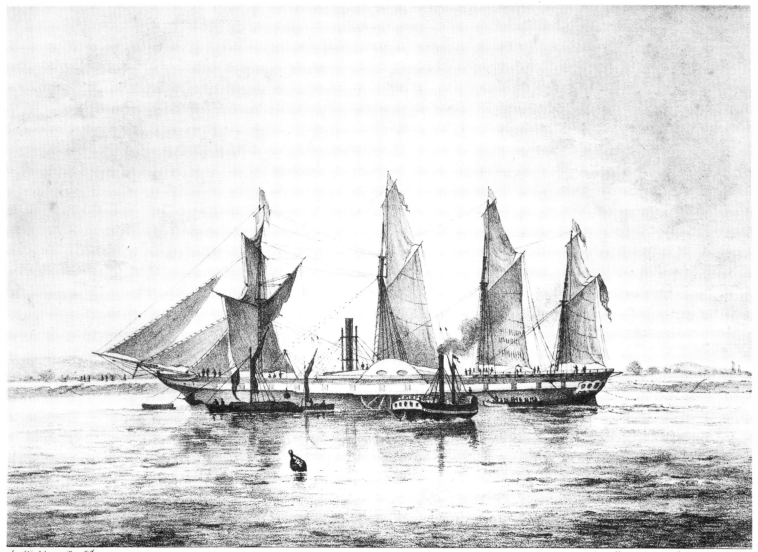

I. Walter. Pinx.d Scale d'y of feet to an Inch.

THE GREAT WESTERN.

Lying at her Moorings at Broad Pill.

Lithographd & Published by T.Bedford, , Broad Quay Bristol.

65 "Launch of THE GREAT BRITAIN Steam Ship AT BRISTOL, JULY 19th 1843." *c.*1843

Lithograph, colour printed and watercolour, 12¾ x 21¼ in. (image)
Inscribed in the plate: *Painted by Joseph Walter—on Stone by T. Picken./Published by George Davey 1 Broad Street, Bristol./Day & Haghe, Lithrs to the Queen.* and as the title, and: *To His Royal Highness Prince Albert. K.G. &c. &c. &c./under whose Auspices this Magnificent Vessel was launched, and who on that occasion honoured our City with his presence,/This print, commemorating that interesting event, is with His. Royal Highness's Gracious permission, respectfully dedicated, by/The Publisher.*
City of Bristol Museum and Art Gallery

The Great Western Steamship Company began work in July 1839 on a sister-ship for the *Great Western* in the hope of attracting a regular transatlantic mail contract and of maintaining a shuttle service for passengers and for goods. Brunel adopted iron for the hull and changed his initial plans for a paddle-steamer to a screw-propelled ship. William Patterson, the Bristol shipbuilder responsible for Brunel's first steamship, also built the *Great Britain* in a specially enlarged dry dock to which she was to return in 1970.

On 19 July 1843, after the Prince Consort had struck a bottle against the bow, the *Great Britain* was slowly towed into the Floating Harbour after the dock sluices had been opened to float the ship for the first time. The *Great Britain* was then the world's largest ship and she represented a major technical advance in ship design and construction. The success of the *Great Western* had led to great hopes of the commercial advantage that the two ships would give Bristol over such rival ports as Liverpool and London.

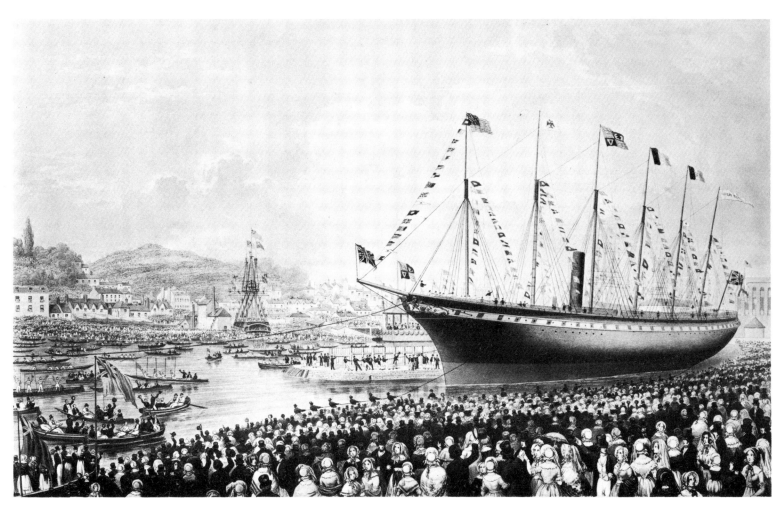

66 The *Great Britain* passing through the entrance lock of Cumberland Basin in the River Avon on the night of 11 December 1844 *c.*1845

Oil on canvas, 16½ x 26 in.
Collection of the S.S. *Great Britain* Project

Walter records the dramatic moment when the *Great Britain* at last got through the Cumberland Basin lock and out of Bristol harbour during the night of 11 December 1844.

The first attempt in the morning to pass straight through on a high spring tide with all the gates open had failed as the ship had stuck in the narrow lock. She was desperately and quickly pulled back to avoid being wedged and suspended as the high tide ebbed. Throughout the day the upper courses of masonry were removed from both sides of the lock using the shear-legs depicted in this painting. Then during the night by the light of blazing tar barrels the *Great Britain* was edged through the lock and into the River Avon and allowed to ground when the tide went out.

67 The *Great Britain* being towed down the Avon Gorge on the start of her voyage to London to complete fitting out on 12 December 1844 *c.*1845

Oil on canvas, 16½ x 26in.
Collection of the S.S. *Great Britain* Project

From near Hotwell, Walter depicts four tugs pulling and nudging the *Great Britain* down the Avon Gorge. She is very high in the water and has only a single mast.

The euphoria surrounding the launching ceremony, a full eighteen months earlier, had quickly subsided when it became apparent to all that the vessel was too large to negotiate the entrance locks at Cumberland Basin, which connected the River Avon with the Floating Harbour, Bristol's non-tidal dock system completed in 1810. The Bristol Dock Company was still struggling to pay off massive debts incurred by this great venture and was clearly in no position to embark on a scheme of major improvements that would enable the *Great Britain* to operate from Bristol. But it also delayed previously agreed

improvements that would have allowed her to get out of the Floating Harbour and many of her fittings had to be removed in order to lighten her.

Brunel appreciated that there was no more splendid setting than the Avon Gorge through which to approach a port but his extraordinary technical and engineering achievements required enormous financial support to bring them to completion. The *Great Britain* could only have operated successfully from the port of Bristol from a new deep-water dock at the mouth of the Avon for which Brunel and others had already submitted plans. But that development took another thirty years to complete.

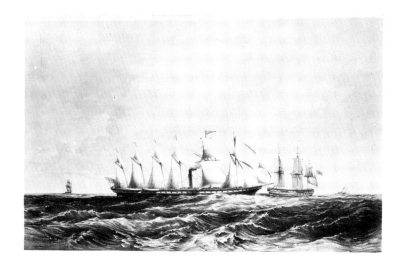

68 The *Great Britain* under full sail and steam *c.*1845

Lithograph, colour printed, 13 x 21 in. (image)
Inscribed in the plate: *Painted by Joseph Walter—On Stone by G. Hawkins/Published by George Davey 1 Broad Street, Bristol./Day & Haghe, Liths. to the Queen/This plate of THE GREAT BRITAIN Steam Ship/ CONSTRUCTED OF IRON BY THOS. R. GUPPY, ESQRE. C.E./at the Works of the Great Western Steam Ship Company at Bristol,/is respectfully dedicated to the enterprising Proprietors/by their obedient Servant/The Publisher.*
City of Bristol Museum and Art Gallery

The novel six-masted schooner rig is very clearly shown and foreshadows the rigs of the last big ocean-going sailing ships of the early years of the twentieth century. The rig worked well and, under sail, the *Great Britain* could match and even exceed her usual speed of twelve and a half knots when driven by her steam engines and screw propeller.

The inscription on this lithograph inaccurately credits Thomas Guppy with the construction of the *Great Britain*. Guppy was a leading Bristol merchant and the third member of the Building Committee to which the directors of the Great Western Steamship Company delegated responsibility. Brunel and his friend and nautical adviser, Captain Christopher Claxton, were the other two members. Guppy was the first person to take up Brunel's proposals for constructing transatlantic steamers and he was instrumental in setting up the Great Western Steamship Company.

69 **The *Great Britain* under steam and sail saluting a ship of war** 1845

Oil on canvas, 17½ x 29¼ in.
Signed and dated: *J. Walter 1845*
Collection of J. C. G. Hill Esq.

The *Great Britain* is depicted firing her signal cannon and dipping her ensign to a naval ship.

The third mast aft of the funnel was to be removed because its sails were quickly fouled by the smoke and the funnel interfered with their effective operation. One of the many novel features of the ship was the position of the bridge between the funnel and the third mast. From here instructions were passed to the stern where the open wheel was in the traditional position.

Sadly this did not prevent the disaster which occurred only a year later when the *Great Britain* ran aground in Dundrum Bay on the coast of Ireland. This brought about the end of the Great Western Steamship Company and also of the brilliant partnership between Brunel and some of the leading members of Bristol's business and shipping community. It was a partnership that had brought unprecedented change to the nation's commercial shipping industry.

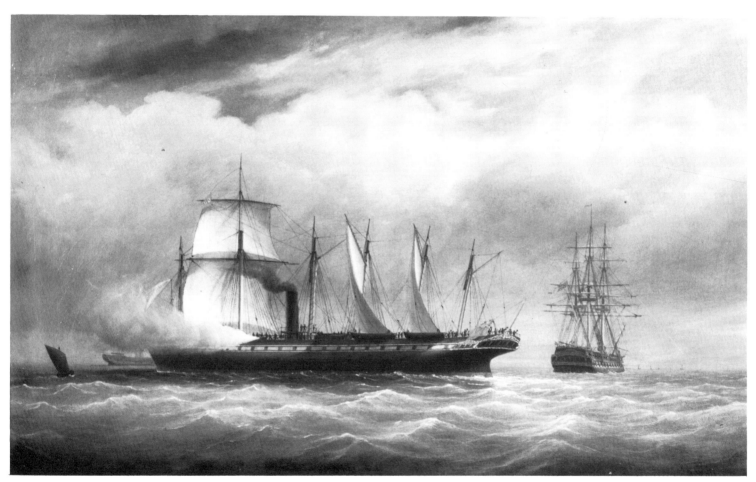

Selected bibliography

ACRL: Avon County Reference Library

BRO: City of Bristol Record Office

Baker, C. Jane: *Thomas Luny, 1759 – 1837* exhibition catalogue Royal Albert Memorial Museum (Exeter 1982)

Bright Family Documents, microfilms, BRO

Brighton, Claude W: *Nicholas Pocock* Cookham Parish Magazine offprint, BRO

Bristol Gazette: J. Walter obituary (19 June 1856), ACRL

Bristol Gazette: J. Walter obituary (26 June 1856), ACRL

Bristol Institution: *Proceeding of the Sub-committee for regulation of the Exhibition Rooms* 1824 – 1845, BRO

Bristol Mirror: J. Walter obituary (14 June 1856), ACRL

Bristol Society of Artists: catalogue of the First Exhibition (1832), ACRL

Bristol Society of Artists: catalogue of the Eleventh Exhibition (1842), ACRL

Brunel, Isambard: *The Life of Isambard Kingdom Brunel, Civil Engineer* First published 1870, intro. by L. T. C. Rolt (1971)

Buchanan, R. A., and Neil Cossons: *The Industrial Archeology of the Bristol Region* (1969)

Buchanan, R. A., and Neil Cossons: *Industrial History in Pictures: Bristol* (1970)

Census, Enumerators returns (1851), microfilm, ACRL

Champion, Richard: Letterbooks, BRO

Champion, Sarah (Fox): Copy of her Journal, 1745 – 1802, Woodbrook College, Birmingham, quoted by Owen, not examined

Cordingly, David, A. Pearsall and H. Preston: *Nicholas Pocock, 1741 – 1821* exhibition catologue National Maritime Museum (London 1975)

Cordingly, David: *Nicholas Pocock (1740 – 1821),* The Old Water-Colour Society's Club, vol. 54 (London 1979)

Corlett, Ewan: *The Iron Ship* (1975)

Crick, Clare: *Victorian Buildings in Bristol* (Bristol, 1975)

Dunman, W. H: *Nicholas Pocock,* exhibition catalogue Bristol Art Gallery (1940)

Farr, Grahame: *Shipbuilding in the Port of Bristol,* National Maritime Museum, Maritime Monographs and Reports, No. 27 (1977)

Farr, Grahame E: *West Country Passenger Steamers* (London, 1956)

Felix Farley's Bristol Journal, concerning engraving of Battle of the Saints' (16 August 1783), ACRL

Gentleman's Magazine: Memoir of Isaac Pocock (December 1835)

Gentleman's Magazine: Memoir of Lieutenant W. I. Pocock, RN (September 1836)

Gill, Jennifer: *The Bristol Scene, Views of Bristol by Bristol Artists from the Collection of the City Art Gallery* (Bristol, 1975)

Graham, Gerald S: *The Royal Navy in the War of American Independence* (London H.M.S.O. 1976)

Hill, Charles: *Private Journal* or account book, 1759 – 72, Private Collection

Hill, John, C. G: *Shipshape and Bristol Fashion* (Liverpool and London)

Ison, Walter: *The Georgian Buildings of Bristol* (London, 1952)

King, John: *Observations on the Exhibition of Works of Art . . . by the Bristol Society of Artists,* 1839 – 49, bound album of contributions to *Bristol Mirror,* City of Bristol Museum and Art Gallery

Latimer, John: *The Annals of Bristol 1600 – 1900* 7 vols (Bristol, 1906)

MacInnes, C. M: *A Gateway of Empire* (Bristol, 1939)

Marshall, Peter: *Bristol and the American War of Independence* Bristol Branch of the Historical Association pamphlet No. 41 (1977)

Merwe, Pieter van der: *The Ingenious Squire: New Aspects of Isaac Pocock (1782 – 1835)* in Theatre Notebook, XXXI (2), (1977)

Minchinton, Walter E: *Richard Champion, Nicholas Pocock and the Carolina Trade* in South Caroline Historical Magazine, LXV (1964)

Northcote, James: The Life of Sir Joshua Reynolds (London 1819)

Owen, Hugh: *Two Centuries of Ceramic Art in Bristol* 2 vols (London, 1873)

Powell, Commander J. W. Damer: *Bristol Privateers and Ships of War* (Bristol, 1930)

Pugsley, Sir Alfred, ed: *The Works of Isambard Kindom Brunel* (London and Bristol, 1976)

Rawlins, Frank L: Letterbooks, c.1908 – 14, BRO

Roget, J. L: *A History of the Old Water-Colour Society* (London, 1891)

Rolt, L. T. C: *Isambard Kingdom Brunel, A Biography* (London, 1957)

Sketchley's Bristol Directory, 1775, with introduction by B. Little (Kingsmead Reprints, 1971)

Spinney, David: *Rodney* (1969)

Thomas, Ethel: *Down the 'Mouth, A History of Avonmouth (1977 and 1981)*

US. Navy: *Naval Documents of the American Revolution* vol. VII

Wells, Charles: *A Short History of the Port of Bristol* (Bristol, 1909)